Isabel Siben

Niki & Jean
de Saint Phalle & Tinguely
POSTERS

Claus von der Osten Collection

With an Index of Posters by /
Mit einem Verzeichnis der Plakate von /
Avec un index des posters par

Claus von der Osten

PRESTEL

MUNICH · BERLIN · LONDON · NEW YORK

This book has been published in conjunction with the exhibition "Niki de Saint Phalle & Jean Tinguely – Posters", Versicherungskammer Bayern, Munich (June 1 – August 28, 2005), Kunstmuseum Heidenheim (December 18, 2005 – February 12, 2006), and Museum für Kunst und Gewerbe, Hamburg (2006)

Edited by Isabel Siben for the Versicherungskammer Bayern

The Editor and Publisher would like to extend their gratitude to the collector Claus von der Osten, Hamburg, and the Museum für Kunst und Gewerbe, Hamburg, for providing the posters

Photography Maria Thrun, Hamburg

Front cover: Poster for the Moderna Museet, Stockholm (Plate 3)

Frontispiece: Niki de Saint Phalle and Jean Tinguely (Photo: Harry Shunk)

The Library of Congress Cataloguing-in-Publication data is available; British Library Cataloguing-in-Publication Data: a catalogue record for this book is available from the British Library; Deutsche Bibliothek holds a record of this publication in the Deutsche Nationalbibliografie; detailed bibliographical data can be found under: http://dnb.ddb.de

Prestel books are available worldwide. Please contact your nearest bookseller or one of the following Prestel offices for information concerning your local distributor:

Prestel Verlag
Königinstrasse 9, 80539 Munich
Tel. +49 (89) 38 17 09-0; Fax +49 (89) 38 17 09-35

Prestel Publishing Ltd.
4 Bloomsbury Place, London WC1A 2QA
Tel. +44 (020) 7323-5004; Fax +44 (020) 7636-8004

Prestel Publishing
900 Broadway, Suite 603, New York, NY 10003
Tel. +1 (212) 995-2720; Fax +1 (212) 995-2733

www.prestel.com

Translated from the German by
Paul Aston (English);
Jean-Philippe Hashold, Joëlle Marelli and
Martine Passelaigue (French)

Design, layout and production: René Güttler
Origination: ReproLine Achter, Munich
Printing and Binding: Druckerei Uhl, Radolfzell

Printed in Germany on acid-free paper

ISBN 3-7913-3404-2

Contents / Inhalt / Sommaire

Foreword

They were a fascinating pair, not least from an artistic point of view—Niki de Saint Phalle (1930–2002), the inventor of the colorful, baroque 'Nanas', and Jean Tinguely (1925–91), the designer of kinetic machines and sound sculptures. Their works are on show in public spaces and leading museums around the world. Yet the fact that both of them were extensively involved in poster work is scarcely known. Following the posters of the artists Pablo Picasso, Keith Haring, Robert Rauschenberg and Joseph Beuys, the posters of Niki de Saint Phalle and Jean Tinguely are being exhibited for the first time as a significant group of works in their own right, in the publication and exhibition series of the Versicherungskammer Bayern (Bavarian Insurance Chamber) in Munich, Germany.

Once again, the particular appeal of artistic posters is evident as a medium of information and personal statement in public spaces. In their totality, the 140 posters are an excellent way of tracing the success story of the two artists from the 1960s onwards. The posters do more than merely document the breadth of their activities, ranging from gallery exhibitions, important retrospectives and actions to their avowed cultural commitment to the theatre, film, jazz festivals, sports competitions and circuses. Their posters are in fact personal testimonies in their own distinctive style and handwriting, and as such provide passionate and direct insight into their working processes and moods.

When you see the poster works of Niki and Jean side by side, it is striking how subtle the reciprocal influences between them were. Only eight of the 140 posters bear witness to the collaboration between the two on major projects such as *Paradis Fantastique* for Expo in Montréal or the Stravinsky fountain in Paris. For all the stylistic and thematic freedom they mutually allowed themselves, they still used the same networks on the art scene. They exhibited at the same galleries and museums and did poster designs commissioned by the same or similar institutions.

My particular thanks to Claus von Osten, a poster collector from conviction, for his loans. He also compiled the catalogue of works for the present publication. Thanks to the enthusiasm of Jürgen Döring of the Arts and Crafts Museum in Hamburg and René Hirner, head of the art museum in Heidenheim, a broad public now has an opportunity to discover the exciting, richly faceted poster work of Niki de Saint Phalle and Jean Tinguely.

Vorwort

Sie gelten als schillerndes Künstlerpaar, nicht zuletzt wegen ihrer faszinierenden Kunst: Niki de Saint Phalle (1930–2002), die Erfinderin der farbenfrohen, barocken ›Nanas‹, und Jean Tinguely (1925–1991), der Konstrukteur kinetischer Maschinen- und Klangplastiken. Ihre Werke stehen auf öffentlichen Plätzen und in den bedeutendsten Museen der Welt. Dass jeder der Künstler auch ein umfangreiches individuelles Plakatwerk geschaffen hat, ist hingegen kaum bekannt. In der Publikations- und Ausstellungsreihe der Versicherungskammer Bayern zu Künstlerplakaten von Pablo Picasso, Keith Haring, Robert Rauschenberg und Joseph Beuys werden nun auch die Plakate von Niki de Saint Phalle und Jean Tinguely als bedeutende Werkgruppe erstmals der Öffentlichkeit vorgestellt.

Abermals bestätigt sich der besondere Reiz des Künstlerplakates als Medium der Information und des persönlichen Statements im öffentlichen Raum: In ihrer Zusammenschau lassen die rund 140 Plakate die Erfolgsgeschichte von Niki de Saint Phalle und von Jean Tinguely ab den 60er Jahren auf das Schönste Revue passieren. Dabei sind die Plakate weit mehr als bloße Dokumente ihres breiten Wirkungsfeldes, das von Galerieausstellungen, bedeutenden Retrospektiven, Aktionen bis zu ihrem ausgeprägten kulturellen Engagement für Theater, Film, Jazzfestivals, Sportwettkämpfe oder Zirkus reicht. Ihre Plakate sind vielmehr persönliche Zeugnisse in eigener Stilistik und Handschrift, sie geben leidenschaftlich und unmittelbar Einblicke in ihre Werkprozesse und Stimmungen.

In der Gegenüberstellung der Plakatwerke von Niki und Jean fällt auf, wie subtil der wechselseitige Einfluss war – lediglich 8 von 140 Plakaten belegen die Zusammenarbeit der Künstler bei Großprojekten, z. B. dem *Paradis Fantastique* für die Expo in Montréal oder des *Stravinsky-Brunnens* für Paris. Bei aller stilistischen und thematischen Freiheit, die sie sich gegenseitig gewährten, nutzten sie doch dieselben Netzwerke der Kunstszene. So wechselten sie sich mit ihren Ausstellungen bei den gleichen Galerien und Museen ab und gestalteten für dieselben oder ähnliche Institutionen Plakataufträge.

Claus von der Osten, Plakatkunstsammler aus Überzeugung, gilt mein besonderer Dank für seine Leihgaben. Er hat auch das Werkverzeichnis für die vorliegende Publikation zusammengestellt. Durch das Engagement von Jürgen Döring vom Museum für Kunst und Gewerbe in Hamburg und René Hirner, Leiter des Kunstmuseums in Heidenheim, bietet sich einer breiten Öffentlichkeit die Chance, das spannende und facettenreiche Plakatwerk von Niki de Saint Phalle und Jean Tinguely zu entdecken.

Avant-propos

S'ils passent pour un couple brillant, leur art fascinant n'y est évidemment pas pour rien : Niki de Saint Phalle (1930-2002), l'inventeuse des «Nanas», baroques et hautes en couleurs, et Jean Tinguely (1925-1991), constructeur de machines cinétiques et de sculptures sonores, ont créé des œuvres figurant désormais sur des places publiques et dans les plus grands musées du monde. On sait à peine, en revanche, qu'une partie de leur œuvre consiste en affiches. Dans la série des publications et des expositions de la Versicherungskammer Bayern, aux affiches d'artistes comme Pablo Picasso, Keith Haring, Robert Rauschenberg et Joseph Beuys viennent à présent s'ajouter celles de Niki de Saint Phalle et de Jean Tinguely, pour la première fois montrées au public.

Une nouvelle fois se confirme ainsi la séduction particulière de l'affiche d'artiste comme véhicule d'information et d'assertion personnelle dans l'espace public : exposées ensemble, ces quelque 140 affiches font défiler devant nous l'histoire d'une réussite, celle de Niki de Saint Phalle et de Jean Tinguely à partir des années 1960. Ces affiches sont d'ailleurs bien davantage que des témoignages de leur vaste terrain d'opérations, expositions dans des galeries, rétrospectives importantes, actions mais aussi engagement marqué pour le théâtre, le cinéma, le jazz, le sport ou le cirque. Ce sont surtout des documents personnels, d'un style et d'une écriture particulière, offrant un accès immédiat et passionné aux processus et aux ambiances de travail.

La confrontation des affiches de Niki et de Jean fait ressortir la subtilité de leur influence réciproque – 8 seulement, sur 140, témoignent de la collaboration des deux artistes à de grands projets, par exemple le *Paradis fantastique* pour l'Expo de Montréal ou la *Fontaine Stravinsky* à Paris. La liberté qu'ils s'accordent mutuellement ne les empêche pas de recourir aux mêmes réseaux de la scène artistique. Ainsi, ils exposent tous deux alternativement dans les mêmes galeries et musées, et réalisent des commandes d'affiches pour les mêmes institutions ou des institutions voisines.

Ma gratitude particulière pour les œuvres prêtées va à Claus von der Osten, collectionneur d'affiches d'art par conviction. C'est lui également qui a recensé la liste des œuvres pour la présente publication. Enfin, c'est grâce à l'engagement de Jürgen Döring du Museum für Kunst und Gewerbe de Hambourg et de René Hirner, directeur du Kunstmuseum de Heidenheim, qu'un large public a aujourd'hui la chance de découvrir cette part riche et captivante de l'œuvre de Niki et Jean.

'It was a game of pingpong between us.'[1]

Jean Tinguely and Niki de Saint Phalle both entered the international art stage in spectacular fashion. Bang! In 1960, a sculpture by Tinguely blew itself up in the garden of the Museum of Modern Art in New York. Two years later the artist got it to explode again in the desert of Nevada, not far from the atomic bomb test area, by way of a political statement. Tinguely called the latter 'happening' *The End of the World*. Crack! Shots were heard on the Paris art scene in 1961 as Niki de Saint Phalle aimed a rifle at a relief equipped with tins of paint. When the bullets went home, dripping paint was splattered all over the surrounding surface. Tinguely and Saint Phalle soon featured as Bonnie and Clyde rebels on the art scene. In the context of the early 1960s their works seemed very provocative, but it was the 'right mixture of provocation and fascination',[2] and came at the right time. They were action artists of the first hour, and they parodied the vaunting of 'abstraction as a world language',[3] the politically inspired pre-eminence of abstract art in the context of the Cold War. As well as doing exploding actions, Tinguely built kinetic sculptures with which the public could automatically produce abstract or *informel* images at the press of a button or by inserting a coin, while Saint-Phalle's shooting actions were a humorous, ironic response to the action paintings of Jackson Pollock.

Both artists were strong, charismatic personalities who vied with each other in their eccentricity. Both of them loved spectacular events and favoured dramatised scenes. They supported each other and spurred each other on to the next, ever larger project, but the irrepressible humour, with a preference for the absurd and mockery, was there right from the first days of their long years of attachment. They first met in Paris in 1956, and became a couple four years later. Though their physical relationship survived only a few years, their mutual inspiration and support lasted until Tinguely's death in 1991.

Jean had made his mark on the art scene early on with his kinetic sculptures, and through him Niki became involved with the Nouveaux Réalistes, a group of artists associated with Pierre Restany, whose subject matter was the 'exciting adventure of real things'.[4] The neo-Dadaist flamboyance of their works made of scrap metal, rubbish, discarded car parts and scraps of posters caused a stir internationally. The group was a loose association of individualists who came together mainly for practical reasons, the principal one being

»Es war wie ein Pingpongspiel zwischen uns.«[1]

Mit spektakulären öffentlichen Auftritten machten Jean Tinguely und Niki de Saint Phalle 1960 und 1961 international auf sich aufmerksam. Bumm! Eine Plastik von Jean Tinguely sprengt sich im Garten des Museum of Modern Art in New York selbst in die Luft. Zwei Jahre später lässt der Künstler als politisches Statement in der Wüste von Nevada, unweit des Atombombentestgebietes, erneut eine Plastik explodieren; er nennt diese Aktion *Das Ende der Welt*. In der Pariser Kunstszene fallen Schüsse: Niki de Saint Phalle zielt mit einem Karabiner auf ein mit Farbdosen präpariertes Relief. Wenn die Kugeln einschlagen, ergießt sich die Farbe in Strömen über die Oberfläche. Tinguely und de Saint Phalle gelten bald als Bonnie and Clyde, als Rebellen der Kunstszene. Anfang der 6oer Jahre wirkten ihre Werke sehr provozierend, »doch sie beherrschten die richtige Mischung aus Provokation und Faszination«[2] und das zum richtigen Zeitpunkt: Sie waren Aktionskünstler der ersten Stunde, und sie parodierten den Anspruch einer »Abstraktion als Weltsprache«[3], der vor dem Hintergrund des Kalten Krieges politisch propagierten Vorrangstellung abstrakter Kunst. Während Tinguely neben seinen Spreng-Aktionen kinetische Plastiken baute, mit denen jedermann auf Knopfdruck oder per Münzeinwurf automatisch abstrakt-informelle Bilder herstellen konnte, wirkten die Schießbilder von Saint Phalles wie eine humorvoll-ironische Antwort auf die Aktionsmalerei von Jackson Pollock.

Beide Künstler waren starke, charismatische Persönlichkeiten, die sich in ihrer Exzentrik gegenseitig übertrafen. Beide liebten sie das Spektakuläre und hatten einen Hang zur großen Inszenierung. Sie unterstützten einander und spornten sich gegenseitig zu immer weiteren und größeren Projekten an. Dabei stand ihr ausgeprägter Humor, mit einer Vorliebe für Absurdität und Ironie, am Anfang ihrer langjährigen Verbundenheit. Niki de Saint Phalle und Jean Tinguely lernten sich 1956 in Paris kennen und wurden vier Jahre später ein Paar. Ihre Liebesbeziehung hielt zwar nur wenige Jahre, dafür währte ihre gegenseitige Inspiration und Unterstützung bis zu Tinguelys Tod 1991.

Jean, der mit seinen kinetischen Plastiken schon früh Anschluss an die Kunstszene gefunden hatte, brachte Niki in Kontakt mit den ›Nouveaux Réalistes‹, jener Künstlergruppe um Pierre Restany, die das »erregende Abenteuer des Realen«[4] mit Werken aus Schrott, Müll, weggeworfenen Autoteilen und Plakatabrissen thematisierte und mit dieser neodadaistischen Geste international Aufsehen erregte. Die Gruppe bestand aus Individualisten, die sich vor allem aus praktischen Erwägungen zusammenfanden, weil es in

« Entre nous c'était comme un jeu de ping-pong[1] »

C'est avec des performances publiques spectaculaires que Jean Tinguely et Niki de Saint Phalle se font connaître dans le monde entier, en 1960 et 1961. Bouma ! Une sculpture de Jean Tinguely explose d'elle-même dans le parc du Museum of Modern Art de New York. Deux ans plus tard, l'artiste fait de nouveau exploser une statue dans le désert du Nevada, non loin de la zone de tests nucléaires, en signe de prise de position politique : il nomme cette action *La fin du monde*. Sur la scène artistique parisienne, les coups tombent : Niki de Saint Phalle tire à la carabine sur un relief confectionné à l'aide de pots de peinture. Jean Tinguely et Niki de Saint Phalle passent bientôt pour Bonnie and Clyde, pour les rebelles de la scène artistiques. Au début des années 1960, leurs œuvres provoquaient, « mais ils maîtrisaient le savant mélange de provocation et de fascination[2] », et cela au bon moment : ils étaient actionnistes de la première heure, parodiant les prétentions de «l'abstraction comme langage universel[3] », place d'honneur réservée, pour des raisons politiques et sur fond de Guerre froide, à l'art abstrait. Tandis que Tinguely, à côté de ses actions explosives, construisait des sculptures cinétiques avec lesquelles tout un chacun pouvait fabriquer des images informelles et abstraites automatiquement en appuyant sur un bouton ou en insérant une pièce de monnaie, les actions-tirs de Niki de Saint Phalle faisaient l'effet d'une réponse ironique pleine d'humour à la peinture-action de Jackson Pollock.

Les deux artistes étaient de fortes personnalités, charismatiques, qui se surpassaient mutuellement dans leur excentricité. Tous deux aimaient le spectaculaire et avaient un penchant pour les grandes mises en scène. Ils se soutenaient mutuellement et s'émulaient dans la réalisation de projets de plus en plus grands. Leur humour manifeste, avec un goût tout particulier pour l'absurdité et l'ironie, était à la base de leur longue complicité. Niki de Saint Phalle et Jean Tinguely firent connaissance en 1956 à Paris, quatre ans plus tard ils étaient en couple. Leur relation amoureuse ne dura certes que quelques années, mais leur inspiration et soutien mutuels perdurèrent jusqu'à la mort de Tinguely en 1991.

Jean, qui était déjà en contact avec la scène artistique grâce à ses sculptures cinétiques, mit Niki en contact avec les « Nouveaux Réalistes », ce groupe d'artistes autour de Pierre Restany qui thématisait «la fascinante aventure du réel[4] » avec des œuvres faites de ferraille, de détritus, de pièces de voitures récupérées à la casse et d'affiches déchirées. Ce geste néoda-

that it is easier to draw attention to innovations in art as a joint enterprise than to do it alone. Among their number were Yves Klein, César, Christo, Arman, Daniel Spoerri, François Dufrène, Raymond Hains, Martial Raysse, Mimmo Rotella, Jean Tinguely and Niki de Saint Phalle (the only female member). As a personable young woman, Niki attracted particular attention. Anyone could take part in her shooting actions. Even American artist friends such as Robert Rauschenberg, Ed Kienholz and Larry Rivers, who like the Nouveaux Réalistes had elevated ordinary life into art, were enthusiastic about them. One event followed another. When John Cage gave a concert at the American embassy in Paris in 1961, Tinguely and Saint Phalle likewise took part alongside David Tudor, Robert Rauschenberg and Jasper Johns. The two of them had exhibits in the *Art of Assemblage* show at the Museum of Modern Art, which demonstrated that mixed-media sculptures made from prosperity's junk were a widespread phenomenon and featured in a wide variety of contexts. It did not take long for Niki and Jean to become a thoroughly established item on the international art scene. The fact that they both assiduously cultivated contacts with friends who were artists, musicians, dancers, gallery owners, museum people and sponsors did much to assist the acceptance and long-term success of their pioneering work. They constantly wrote witty, imaginative letters with updates of their current projects.

Around the same time (in the early 1960s), they discovered the attractions of posters based on original designs, and made use of them as a publicity medium to advertise their numerous activities to the general public. The 140 richly faceted posters they produced in the ensuing years trace in a very personal and impressive fashion the success story of two artists who worked together and as individuals in a wide variety of disciplines.

'I'm a technical artist' [5]

A Jean Tinguely exhibition at the Galerie Handschin, Basle 1962 *(cat. 50)*: 'Never has there been such a deafening row on varnishing day. Never has there been such hearty, unforced laughter on varnishing day. Never have so many people tripped over wires, pressed buttons, been splattered with oil or almost scalped by bits of machinery on varnishing day. Never before were more pictures painted by the public on varnishing day than the artist himself painted. Overall it was a unique varnishing day, and it opened a wonderful exhibition. You can't get away from the

der Gemeinschaft leichter ist, auf neue Tendenzen der Kunst aufmerksam zu machen, als im Alleingang. Zu ihnen gehörten Yves Klein, César, Christo, Arman, Daniel Spoerri, Francois Dufrêne, Raymond Hains, Martial Raysse, Mimmo Rotella, Jean Tinguely und Niki de Saint Phalle – letztere als einziges weibliches Mitglied. In dieser Konstellation erregte die attraktive junge Frau besonderes Aufsehen. An ihren Schießhappenings durfte sich jeder beteiligen. Auch die amerikanischen Künstlerfreunde Robert Rauschenberg, Ed Kienholz und Larry Rivers, die wie die ›Nouveaux Réalistes‹ den Alltag zur Kunst erklärt hatten, waren davon begeistert. Ein Ereignis jagte das nächste. Als John Cage 1961 in der amerikanischen Botschaft in Paris ein Konzert gab, wirkten neben David Tudor, Robert Rauschenberg und Jasper Johns auch Tinguely und de Saint Phalle mit. Es folgte ihre Teilnahme an der Ausstellung ›The Art of Assemblage‹ im Museum of Modern Art, mit der gezeigt werden konnte, dass Mixed-Media-Plastiken aus Wohlstandsmüll ein weit verbreitetes Phänomen waren und aus verschiedensten Intentionen zum Einsatz kamen. Innerhalb kürzester Zeit waren Niki und Jean in der internationalen Kunstszene bestens etabliert. Und beide pflegten ihre Kontakte zu befreundeten Künstlern, Musikern, Tänzern, Galeristen, Museumsleuten und Förderern – bestimmt ein wesentlicher Aspekt für ihren bahnbrechenden und anhaltenden Erfolg. Mit fantasievoll gestalteten Briefen informierten sie laufend über ihre aktuellen Projekte.

Etwa zur gleichen Zeit, Anfang der 60er Jahre, entdeckten sie auch den Reiz des eigenständig gestalteten Künstlerplakates und machten es sich als Medium des öffentlichen Raumes zunutze, um auf ihre zahlreichen Aktivitäten hinzuweisen. Es entstanden rund 140 facettenreiche Plakate, die die Erfolgsgeschichte beider Künstler einschließlich ihrer interdisziplinären Interessensgebiete auf persönliche und eindrucksvolle Art Revue passieren lassen.

»Ich bin ein Technikkünstler« [5]

Basel 1962, Galerie Handschin, Ausstellung von Jean Tinguely *(Cat. 50)*: »Noch nie herrschte an einer Vernissage ein derart ohrenbetäubender Lärm. Noch nie wurde an einer Vernissage so herzlich und unbeschwert gelacht. Noch nie waren an einer Vernissage so viele Leute, die über Drähte stolperten, auf Knöpfe drückten, Ölflecken bekamen oder von Maschinenteilen nahezu skalpiert wurden. Noch nie wurden an einer Vernissage mehr Bilder vom Publikum gemalt, als der Künstler selber ausgestellt hatte. Überhaupt war es eine einmalige Vernissage und sie eröffnete eine wunderbare Ausstellung. Man kann sich dem Zauber von Jean Tinguely

daïste suscita l'intérêt du monde entier. Le groupe se composait d'individualistes qui étaient réunis pour des raisons pratiques, parce qu'il est plus facile d'attirer l'attention sur les nouvelles tendances lorsque l'on est en groupe qu'en faisant cavalier seul. Parmi eux se trouvaient Yves Klein, César, Christo, Arman, Daniel Spoerri, François Dufrêne, Raymond Hains, Martial Raysse, Mimmo Rotella, Jean Tinguely et Niki de Saint Phalle – cette dernière étant la seule femme. Au sein de cette constellation, la séduisante jeune femme jouissait d'une considération particulière. Tout le monde pouvait participer à ses actions-tirs. Même les amis artistes américains Robert Rauschenberg, Ed Kienholz et Larry Rivers, qui, à l'instar des « Nouveaux Réalistes », avaient déclaré le quotidien comme art, étaient enchantés. Un événement chassait l'autre. Quand John Cage donna un concert en 1961 à l'ambassade des États-Unis à Paris, à côté de David Tudor, Robert Rauschenberg et Jasper Johns, Jean Tinguely et Niki de Saint Phalle étaient aussi de la partie. S'ensuivit leur participation à l'exposition « The Art of Assemblage » au Museum of Modern Art qui fut l'occasion de montrer que les sculptures mixed-media réalisées à base de déchets de la société de consommation étaient un phénomène répandu et résultant d'intentions diverses. En l'espace de peu de temps, Niki et Jean se retrouvèrent fort bien placés sur la scène artistique internationale. Et tous deux entretenaient des liens avec des amis artistes, musiciens, danseurs, galeristes, gens de musée et mécènes – un aspect certainement essentiel de leur succès novateur et durable. Dans des lettres très originales, ils tenaient leurs amis au courant de l'avancement de leurs projets en cours.

À peu près à la même époque, au début des années 1960, ils firent la découverte du charme de l'affiche d'artiste conçue indépendamment et en tirèrent avantage comme moyen venant de l'espace public pour faire référence à leurs nombreuses activités. Environ 140 affiches très diverses virent le jour, passant en revue l'histoire du succès des deux artistes ainsi que leurs centres d'intérêt interdisciplinaires d'une manière personnelle et impressionnante.

« Je suis un artiste mécanicien [5] »

Bâle 1962, Galerie Handschin, Exposition de Jean Tinguely *(cat. 50)*: « Jamais vernissage n'avait connu un tel vacarme. Jamais dans un vernissage on n'avait ri avec autant de cœur et d'insouciance. Jamais dans un vernissage tant de gens ne s'étaient accrochés dans des fils de fer, n'avaient appuyé sur des boutons, ne s'étaient tachés d'huile ou presque scalpés par des éléments de machine. Jamais le public

magic of Jean Tinguely—even three miles upwind, you still hear his sculptures on the way home. One must just be going past my window now. Or is it a tram derailing?'[6]

This enthusiastic commentary pinpoints the special strength of Tinguely's sculptures— they are an interactive event. He himself described them as 'Sisyphuses' he had condemned to quite specific, absurd movements.[7] More than any other kinetic artist, Tinguely knew how to give his sculptures a dimension that drew people in. With Tinguely, viewers are participants, able to experience the sculptures with all their senses and track down the sources of sounds or noises by walking round them. The works seem to have a life of their own and impressively evoke diverse moods, ranging from the cheerful or grotesque to the macabre.

He achieves the same effect with his graphic work as well. Looking through the pages of drawings is a reminder of synaesthetic events one once experienced. The early posters by Tinguely are based first and foremost on a wealth of working sketches that he did from the mid-1950s onwards.[8] Some of these can be definitely be allocated to the sculptures he completed (thanks inter alia to the titles of the works handwritten on them).[9] Typical of Tinguely is the associative, spontaneous drawing with which he quickly notes down initial ideas for the design. On some of his gallery and museum posters (pl. 33, 47; cat. 55, 59, 61, 62, 71) he presents various 'machines' by assembling several drawings in the manner of a catalogue, where they begin to swing into action in our imagination, even on paper. Tinguely suggests this by the simultaneous presentation of different viewpoints, arrows and over-drawings. Discernible are for example variants of his Spirales,[10] Bascules,[11] Santana,[12] Balubas,[13] or MK IV or Sisyphus,[14] Eos,[15] Char I or Marilyn[16] and La Fontaine.[17]

Tinguely was obsessed with technical things. The theme of motion expressed in revolving wheels, spirals or other objects, offered him an inexhaustible terrain. He generated numerous variants from every kind of movement, adding humour as a bonus element. A photo poster bears witness to the enthusiasm his structures call forth: in Cyclograveur a laughing, elegant woman sits pedalling an exercise bike (pl. 41), thereby engraving a metal plate. Another machine with the Dadaist fantasy name Rotazaza (pl. 34) hurls balls into the room that exhibition visitors have thrown at it. Along with a number of handwritten technical details, Tinguely notes on the poster that this sculpture attracts the most museum visitors and calls it—with an

nicht entziehen – selbst drei Meilen gegen die Winde hört man seine Skulpturen noch auf dem Heimweg. Jetzt gerade muss eine vor meinem Fenster vorbeigehen. Oder ist es eine Tram, die entgleist?«[6]

Dieser begeisterte zeitgenössische Kommentar veranschaulicht, worin die besondere Stärke von Tinguelys Plastiken liegt: Sie sind ein interaktives Ereignis. Er selbst beschrieb sie als »Sisyphosse«, die er zu ganz bestimmten, absurden Bewegungen verurteilt habe.[7] Wie kein anderer Kinetiker verstand es Tinguely, seinen Plastiken eine menschlich-berührende Dimension zu verleihen. Bei Tinguely wird der Betrachter zum Akteur, er kann die Plastiken mit allen Sinnen erfahren und spürt, indem er sie umschreitet, der Quelle ihrer Klänge bzw. Geräusche nach. Sie scheinen ein Eigenleben zu haben und evozieren eindrücklich unterschiedliche Stimmungen, vom Heiteren, Grotesken bis zum Makabren.

Diese Wirkung gelingt ihm auch mit seinem grafischen Werk. Die Betrachtung der Skizzenblätter bringt das einmal erlebte synästhetische Ereignis wieder in Erinnerung. Die frühen Plakate Tinguelys basieren in erster Linie auf dem Fundus seiner zahlreichen Arbeitsskizzen, die er seit Mitte der 50er Jahre anfertigte.[8] Sie lassen sich zum Teil eindeutig seinen realisierten Plastiken zuordnen (auch durch handschriftlich beigefügte Werktitel).[9] Charakteristisch für Tinguely ist die assoziative, spontane Zeichnung, mit der er seine konstruktiven, gestalterischen Gedanken in Schnelligkeit notierte. Durch die katalogartige Zusammenstellung mehrerer Zeichnungen auf einigen seiner Galerie- und Museumsplakate (Taf. 33, 47; Cat. 55, 59, 61, 62, 71) präsentiert er verschiedene ›Maschinen‹. In unserer Vorstellung treten sie bereits auf dem Papier in Aktion: Dies suggeriert Tinguely durch simultane Wiedergabe verschiedener Ansichten, Pfeile und Überzeichnungen. Zu erkennen sind unter anderem Varianten seiner Spirales,[10] Bascules,[11] Santana,[12] Balubas,[13] sowie MK IV oder Sisyphus,[14] Eos,[15] Char I oder Marilyn[16] und La Fontaine.[17]

Tinguely war technikbesessen. Das Thema Bewegung, zum Ausdruck gebracht durch sich drehende Räder, Spiralen oder andere Objekte, bot ihm ein unerschöpfliches Terrain. Aus jeder Bewegungsart generierte er zahlreiche Varianten – und das auf humorvolle Weise. Ein Fotoplakat zeugt von der Begeisterung, die seine Konstruktionen hervorrufen: Lachend radelt eine elegante Dame auf dem Standfahrrad Cyclograveur (Taf. 41) und graviert damit eine Metallplatte. Eine andere Maschine mit dem dadaistischen Fantasienamen Rotazaza (Taf. 34) schleudert Bälle in den Raum, die ihr die Ausstellungsbesucher zugeworfen haben. Neben einigen handschriftlichen technischen Angaben notiert Tinguely auf dem Plakat, dass diese Plastik die

n'avait peint plus de tableaux que l'artiste n'en exposait lui-même. C'était un vernissage unique qui ouvrait une merveilleuse exposition. Personne ne peut résister au charme de Jean Tinguely – même à trois miles de distances et à contre vent, on entend encore ses sculptures en rentrant chez soi. Justement l'une d'entre elles vient de passer sous ma fenêtre. Ou est-ce un tramway qui vient de dérailler[6] ?»

Par son enthousiasme, ce commentaire de l'époque illustre en quoi réside la force singulière des sculptures de Tinguely : elles constituent un événement interactif. Il les décrivait lui-même comme des « Sisyphes » qu'il aurait condamnés à des mouvements très particuliers, absurdes[7]. Comme aucun autre cinéticien, Tinguely savait donner à ses sculptures une dimension touchante et humaine. Avec Tinguely, le spectateur devient acteur, il peut appréhender les sculptures à l'aide de tous ses sens et remonte, en tournant autour d'elles, à la source de leurs sons et bruissements. Elles donnent l'impression d'avoir leur propre vie et évoquent de façon saisissante différentes humeurs de la sérénité jusqu'au macabre en passant par le grotesque.

Il parvient aux mêmes effets dans son œuvre graphique. La contemplation des esquisses rappelle l'expérience synesthésique vécue. Les premières affiches de Tinguely reposent en première ligne sur le fonds des nombreuses esquisses de travail qu'il a réalisées à partir de la moitié des années 1950[8]. On peut en partie les mettre en relation avec ses sculptures (notamment grâce aux titres d'œuvre ajoutés à la main)[9]. Le dessin associatif, spontané, est caractéristique de Tinguely qui notait ainsi rapidement ses pensées constructives et formelles. À l'aide d'une compilation à la manière d'un catalogue de plusieurs de ses dessins présents sur certaines de ses affiches de galerie ou musée (pl. 33, 47; cat. 55, 59, 61, 62, 71), il présente différentes « machines ». Dans notre conscience, elles entrent en action alors qu'elles sont encore sur le papier : Tinguely suggère le mouvement en dessinant en même temps plusieurs vues, des flèches et des traits sur lesquels il repasse plusieurs fois. On reconnaît des variantes de ses Spirales,[10] Bascules,[11] Santana,[12] Balubas,[13] ainsi que de MK IV ou Sisyphe[14], Eos,[15] Char I ou Marilyn[16] et La Fontaine.[17]

Tinguely était fou de technique. Le thème du mouvement, exprimé par des roues en mouvement, des spirales ou autres objets, constituait un terrain inépuisable. De toute sorte de mouvement, il générait d'innombrables variantes – et de manière humoristique. Une affiche photo souligne l'enthousiasme que ses constructions suscitent : tout en riant, une dame élégante pédale sur le vélo d'appartement Cyclograveur

ironic side-swipe at the popularity of Niki de Saint Phalle—a prototype 'anti-Nana'. Under the absurd title of *Requiem for a Dead Leaf* he set huge wheel mechanisms going at Expo 1967 in Montréal just to make a small white metal leaf tremble *(pl. 35)*. At first sight, the chaotic collection of wheels in the poster for the exhibition at the Alexander Iolas gallery in Geneva in 1964 looks like a free improvisation *(pl. 32)*. On closer inspection, it turns out to be a mock-up[18] for the monumental sound sculpture *Eureka*, which Tinguely did for the Swiss provincial exhibition in Lausanne the same year. The poster is also an early example of his playful, jocular handling of the stamps, typography and collage elements that he used to deal with his voluminous correspondence quickly.[19] He carried the stuff about with him all the time in a plastic bag,[20] including favourite accessories such as pens, confetti, car stickers, sheets of Letraset and a rhinoceros stamp with question marks in the speech bubble that recurs in many posters, as if Tinguely were challenging himself.

From 1970 his poster designs became increasingly freer and more colorful, with the use of collage elements and painted highlights. This was in line with the parallel tendency towards using color in his sculptures at the time. In the 1960s, he had generally painted them black, but now he was beginning to make increasing use of color highlights to underline the impression of movement and dynamism. Tinguely enthusiastically set about making compositions from the most heterogeneous materials and pictorial elements. For example, what do the Stars and Stripes, ice cream, cowboys and Indians have to do with his exhibition in the foyer of the museum in Solothurn in 1974 *(pl. 45)*? A dynamically curved sketch provides the answer: it's about his sculpture *Chaos*,[21] which he did in Columbus (Indiana) the same year.

Tinguely confidently acts the part of the international artist working in a wide range of fields. How sure he was that his name already meant something and acted as a magnet for the public is indicated by the series of posters he did for the first major retrospective, which he threw off quite casually *(pl. 42)*. For example, on the one for the Kunsthalle in Basle he laconically just wrote his name, the subject of the exhibition and the place and date in handwriting on a small card, making several mistakes as he did so and unabashedly crossing them out. Once again the little rhinoceros stamp came in handy. It can't have taken Tinguely more than a minute to scrawl down this rough—perhaps it was an ironic message to the museum in his home town Basle, which

meisten Museumsbesucher anlocke und nennt sie – mit einem ironischen Seitenhieb auf die Popularität von Niki de Saint Phalle – »Prototyp einer Anti-Nana«. Unter dem absurden Titel *Requiem für ein totes Blatt* setzt er auf der ›Expo 1967‹ in Montréal riesige Räderwerke in Gang, nur damit ein kleines weißes Metallblatt erzittert *(Taf. 35)*. Die chaotische Räderansammlung auf dem Plakat für die Galerieausstellung bei Alexander Iolas in Genf 1964 wirkt auf den ersten Blick wie eine freie Improvisation *(Taf. 32)*. Bei genauerer Betrachtung erweist sie sich als Ideenskizze[18] zur monumentalen Klangplastik *Heureka*, die Tinguely im gleichen Jahr für die Schweizer Landesausstellung in Lausanne schuf. Das Plakat ist außerdem ein frühes Beispiel für seinen spielerisch-scherzhaften Umgang mit Stempeln, Typografie und mit Collage-Elementen, die er auch zur schnellen Erledigung seiner zahlreichen Korrespondenzen[19] verwendete. Das Material trug er ständig in einer Plastiktasche bei sich,[20] darunter bevorzugte Accessoires wie Federn, Konfetti, Aufkleber aus dem Automobilbereich, Lettrasetbuchstaben und der Rhinozerosstempel mit Fragezeichen in der Sprechblase, der auf vielen Plakaten wiederkehrt, als wollte Tinguely sich selbst in Frage stellen.

Durch Collage-Elemente und malerische Akzente wurden seine Plakatgestaltungen ab 1970 zunehmend freier und farbenfroher. Dies entspricht der Tendenz zur Farbe bei den Plastiken dieses Zeitraums: In den 60er Jahren hatte er sie grundsätzlich schwarz bemalt, nun setzte er vermehrt auf Farbakzente, um den Eindruck von Bewegung und Dynamik zu unterstreichen. Mit Begeisterung ging Tinguely daran, Kompositionen aus den heterogensten Materialien und Bildelementen zu schaffen. Was haben etwa die amerikanische Flagge, Eiscreme, Indianer und Cowboys mit seiner Ausstellung im Museumsfoyer in Solothurn 1974 zu tun *(Taf. 45)*? Eine dynamisch geschwungene Skizze bringt die Auflösung: Es handelt sich um seine Plastik *Chaos*,[21] die er im gleichen Jahr in Columbus/Indiana realisierte.

Tinguely gibt sich selbstbewußt als internationaler, in verschiedensten Kontexten agierender Künstler. Wie sehr er sich darauf verließ, dass sein Name bereits Programm war und wie ein Publikumsmagnet wirkte, zeigt die Serie seiner Plakate für die erste große Retrospektive, die er ganz beiläufig entwarf *(Taf. 42)*: Für die Kunsthalle Basel z.B. notiert er lapidar handschriftlich auf einem kleinen Zettel seinen Namen, Ausstellungsthema, Ort und Datum, wobei er sich mehrfach verschreibt und dies kurzerhand durchstreicht. Der kleine Rhinozerosstempel kommt wieder zum Einsatz. Diesen Entwurf hat Tinguely in maximal einer Minute hingekritzelt – war es vielleicht eine ironische Grußadresse an

(pl. 41) et grave ainsi une plaque de métal. Une autre machine au nom dadaïste et imaginaire de *Rotozaza (pl. 34)* lance dans la pièce des balles que les visiteurs de l'exposition lui ont jetées. Outre quelques annotations techniques manuscrites, Tinguely précise sur l'affiche que cette statue attire la plupart des visiteurs et l'appelle – en faisant ironiquement allusion à la popularité de Niki de Saint Phalle – « prototype d'une anti-nana ». Sous le titre absurde *Requiem pour une feuille morte*, il met en mouvement à l'Expo 1967 de Montréal un gigantesque mécanisme de roues pour ne faire vibrer qu'une petite feuille de métal blanc *(pl. 35)*. L'ensemble chaotique de roues sur l'affiche de l'exposition de la galerie Alexander Iolas à Genève, en 1964, donne l'impression, au premier coup d'œil, d'une libre improvisation *(pl. 32)*. En y regardant de plus près, elle se dévoile comme l'esquisse[18] de la monumentale sculpture sonore *Heureka* que Tinguely créa la même année pour l'exposition nationale suisse à Lausanne. En outre, l'affiche est un exemple précoce de son rapport ludique et amusé aux tampons, à la typographie et aux éléments de collage auxquels il avait également recours pour écrire rapidement ses nombreuses lettres[19]. Il avait toujours avec lui le matériel dans un sac en plastique[20], il affectait les accessoires comme les plumes, les confettis, les autocollants d'automobile, les lettres autocollantes et le tampon rhinocéros avec point d'interrogation dans la bulle qui revient sur beaucoup d'affiches, comme si Tinguely voulait se mettre lui-même en question.

Avec les éléments de collage et les accents picturaux, ses affiches deviennent à partir de 1970 de plus en plus libres et plus colorées. Cela correspond à une tendance à la couleur dans les sculptures de la même période : dans les années 1960, il les peignait essentiellement en noir ; désormais, il accorde de plus en plus d'importance aux accents de couleur pour souligner l'impression de mouvement et de dynamisme. C'est avec enthousiasme que Tinguely s'est mis à créer des compositions à partir de matériaux et d'éléments d'images les plus hétérogènes. Ainsi, le drapeau américain, la crème glacée, les Indiens et les cow-boys, qu'ont-ils à voir avec son exposition au Museumsfoyer de Soleure en 1974 *(pl. 45)* ? La réponse nous est apportée par une esquisse au cercle dynamique : il s'agit de la statue *Chaos*[21] qu'il a réalisée la même année à Columbus (Indiana).

Tinguely se comporte délibérément comme un artiste international agissant dans différents contextes. Le fait qu'il croyait profondément que son nom était déjà tout un programme et agissait comme un aimant à public transparaît dans une série d'affiches pour sa première

up to that time had not purchased anything by him. The poster was printed in large format. In just five weeks, visitor figures built up (despite—or perhaps because of—the unattractive poster) to a record 27,000.[22] The posters for the other stops of the retrospective were comparatively more 'attractive', but the noting of various telephone numbers and dates on them suggests that they too were thrown off incidentally, made up of similar readymade bits.

A particularly punchy image is the combination of a spanner and butterfly—as absurd as it is poetic—on the poster for the Kestnergesellschaft in Hanover (pl. 43). It recalls Lautréamont's analogy 'as beautiful as the accidental encounter of an umbrella and a sewing machine on a dissecting table,'[23] anticipating the Surrealist practice of linking non-causally related motifs. Tinguely worked off his taste for the monumental in his sculptures. In the small format of collages for posters and letters he sought relaxation. He wrote on a questionnaire from Margrit Hahnloser that his feelings piled up so quickly that 'sometimes a color or a flower sticker can take their place'.[24] In the posters he made greater use of color, and liberated his trademark wheel mechanism from the functional context of transmissions. Wonderful rotating abstract color improvisations came out of it. They are particularly effective against Tinguely's favourite black background. The darker or more macabre side of his late sculptures, where Tinguely often incorporated animal skulls in altar-like structures, is rarely evident in his posters (pl. 58; cat. 104). We can thus count his posters among the 'diversion manoeuvres' that he used to steer attention away from the 'bad' impression that his machines sometimes created.[25]

In fact, his interests went well beyond an 'obsession' for mechanical art. He created a festive mood with pyrotechnics of paint, feathers and confetti on his posters for the Dromesko Circus and the Montreux Jazz Festival (pl. 61, 52). A picture puzzle in Basle that began with the symbol of a rose and a construction worker was only solved weeks later with an all-over collage in the fifth version of the poster advertising the Basle theatre season (pl. 44 a–e). And, evoking his subject's Dadaist links, Tinguely announced a revival of Tristan Tzara's famous theatrical sensation *The Gas Heart* with a humorous letter-collage *Dani Dada Tzara Dasga… (pl. 38)* on a poisonous green background.

das Museum seiner Heimatstadt Basel, das bis dato von ihm noch nichts erworben hatte? Das Plakat wurde großformatig gedruckt. Die Besucherzahlen stiegen trotz (oder vielleicht gerade wegen) des unattraktiven Plakats auf eine Rekordhöhe von 27000 in nur fünf Wochen.[22] Die Plakate für die weiteren Stationen der Retrospektive sind im Vergleich dazu ›ansprechender‹, doch der Vermerk irgendwelcher Telefonnummern und Termine auf ihnen zeigt, dass auch sie ganz nebenbei, aus zum Teil sehr ähnlichen Versatzstücken entstanden sind.

Eine besondere Pointe ist die gleichermaßen absurde und poetische Kombination von Schraubenschlüssel und Schmetterling auf dem Plakat für die Kestnergesellschaft in Hannover (Taf. 43). Man erinnert sich an das Motto »Schön wie die zufällige Begegnung eines Regenschirms mit einer Nähmaschine auf einem Seziertisch«[23], mit dem Lautréamont die surreale Praxis nonkausaler Motivverknüpfungen vorwegnahm. Mit seinen Plastiken hat Tinguely monumentale Entsprechungen geschaffen. Im kleinen Format der Collage für Plakate und Briefe suchte er Entspannung: Auf einem Fragebogen von Margrit Hahnloser schreibt er, dass seine Gefühle so schnell seien und »sich übereinander anhäufen, so dass manchmal Farbe oder ein Klebeblümchen anstelle treten kann«.[24] Auch bei den Plakaten setzt er die Farbe verstärkt ein und löst sein Markenzeichen, das Räderwerk, aus dem Funktionszusammenhang der Transmissionen. Es entstehen wunderbare rotierende abstrakte Farbimprovisationen. Besonders ausdrucksstark sind sie vor dem von Tinguely geschätzten schwarzen Fond. Die düstere bzw. makabre Seite seines plastischen Spätwerks, in dem oftmals Tierschädel in altarartige Aufbauten integriert sind, ist in seinen Plakaten dagegen nur selten präsent (Taf. 58; Cat. 104). Somit dürfen wir auch sein Plakatwerk zu seinen »Diversionsmanövern« rechnen, mit denen Tinguely den »schlechten« Eindruck, den seine Maschinen hinterlassen könnten, kaschieren wollte.[25] Tatsächlich gingen seine Interessen weit über die »Obsession« für die Maschinenkunst hinaus: Mit einem Feuerwerk aus Farben, Federn und Konfetti macht er auf seinen Plakaten Stimmung für den Zirkus Dromesko und das Jazzfestival in Montreux (Taf. 61, 52). Ein Bilderrätsel in Basel, das mit dem Symbol einer Rose und eines Bauarbeiters begann, findet erst nach Wochen mit der ›all over‹-Collage der 5. Plakatversion seine Auflösung – es ist ein Werbeplakat für die Basler Theatersaison (Taf. 44 a–e). Und im Verweis auf seine dadaistischen Vorbilder kündigt Tinguely auf giftgrünem Plakat die Wiederaufführung von Tristan Tzaras berühmtem Theater-Eklat *Das Gasherz* mit der humorvollen Buchstaben-Collage »Dani Dada Tzara Dasga…« an (Taf. 38).

grande rétrospective qu'il a esquissée comme au petit bonheur (pl. 42) : pour la Kunsthalle de Bâle, il note brièvement à la main sur une petite feuille son nom, le thème de son exposition, le lieu et la date tout en faisant plusieurs fautes et raturant sans trop réfléchir. Le petit tampon rhinocéros reprend du service. Tinguely a gribouillé cette esquisse en une minute maximum – s'agissait-il peut-être d'une adresse ironique à l'attention du musée de Bâle, sa ville natale, qui jusqu'alors ne lui avait rien acheté ? L'affiche a été imprimée en grand format. Le nombre de visiteurs augmenta malgré (ou peut-être du fait de) l'affiche peu attrayante pour atteindre le niveau record de 27 000 visiteurs en seulement cinq semaines[22]. Les affiches des autres lieux de l'exposition sont en comparaison plus « affriolantes », même si la mention de quelconques numéros de téléphones ou de rendez-vous trahit qu'elles aussi ont vu le jour tout à fait par hasard, en partie des mêmes éléments.

La combinaison en quelque sorte absurde et poétique de clefs de bricolage et de papillon sur l'affiche pour la Kestnergesellschaft à Hanovre constitue la pointe (pl. 43). On se souvient du slogan « beau comme la rencontre fortuite sur une table de dissection d'une machine à coudre et d'un parapluie[23] », avec lequel Lautréamont initia la pratique surréaliste d'assemblage non causal de motifs. Tinguely a, par ses sculptures, créé d'énormes associations. Dans le petit format du collage pour les affiches et les lettres, il recherchait l'apaisement : dans un questionnaire de Margrit Hahnloser, il écrit que ses sentiments sont si rapides et « s'accumulent tellement, que c'est parfois de la couleur ou une petite fleur collée qui les supplantent[24] ». De même pour les affiches, il utilise de plus en plus la couleur et libère sa marque d'artiste, le mécanisme à roues, de son contexte fonctionnel de transmissions. Des improvisations chromatiques abstraites à rotation voient le jour. Elles sont particulièrement expressives devant le fond noir très apprécié de Tinguely. Le côté sombre, voire macabre, de son œuvre sculptée tardive, dans laquelle des crânes d'animaux prennent place sous forme d'autels, n'est en revanche que rarement présent dans ses affiches (pl. 58; cat. 104). Ses affiches comptent donc parmi les « manœuvres de diversion » à l'aide desquelles Tinguely voulait cacher la « mauvaise » impression que ses machines pouvaient laisser[25]. En effet, ses intérêts allaient bien au-delà de son « obsession » de l'art mécanique : dans un feu d'artifice de couleurs, de plumes et de confetti, il donne le ton sur ses affiches pour le cirque Dromesko et le Festival de Jazz de Montreux (pl. 61, 52). Une charade à Bâle qui commence sur le symbole d'une rose et d'un

'Paradis Fantastique was actually an amorous game between Jean and me: his masculine black machines attacked my colorful, sunny sculptures. It was a battle—a love battle.'[26]

Niki de Saint Phalle and Jean Tinguely loved involving the public in interactive games. A number of large sculptures they planned thus acquired the character of events. In all, they did eight posters for these fantastic joint projects, the first of which was the huge walk-in Nana *Hon* (She) in 1966. The poster *(pl. 1)* for the exhibition in the Moderna Museet in Stockholm is typical of Tinguely's style, but since the motif in it is a Nana, whose originator was Saint Phalle, it is probably best considered as a joint work. The sketch outlines the figure of the Nana and the structure of her inner life. Arrows and flights of steps mark the visitor's itinerary, who entered the anthropomorphic structure through a doorway (vagina). Squares refer to various rooms, which are marked on the poster with letters. It must surely have been great fun to explore the inner life of the female Gulliver. *Hon* included an aquarium with goldfish, a cinema showing Greta Garbo films, a gallery with fake pictures à la Dubuffet and a dimly lit bar and planetarium in the two breasts. Traffic lights controlled the flow of visitors, hostesses offered small refreshments, and sculptures by Tinguely and Per Olov Ultvedt emitted noises that mingled with organ music by Bach. *Hon* was a great hit with the public, inducing over 100,000 visitors in only three months to come and be astonished by this 'total art', which amounted to a jaunty rejection of the taboos on sexuality.

A year later, Tinguely and Saint Phalle gained a major sculptural commission for the French pavilion at the world expo in Montréal. They came up with the *Paradis Fantastique*, a diverse ensemble of colorful Nanas and fantastic beasts being attacked by Tinguely's black-painted machines on the roof of the pavilion. Their distinctive styles came across as a contrast between masculine and feminine, and the ensemble is more or less a comic battle of the sexes. The two posters (for the Albright Knox Gallery and Moderna Museet; *pl. 2, 3*) reflect the subsequent history of the immense installation, which finished up in Stockholm in 1971 after visiting Buffalo and spending a whole year in New York's Central Park. The public loved it everywhere. Niki called the sculptural ensemble an 'amorous game'[27] and 'love battle'[28] between her and Jean. Their shared love of art would outlast their physical love affair. As Niki summed it up later: 'Jean—the great love of your life was in any case your work, and the same went and still goes for me.

»Das Paradis Fantastique war eigentlich ein Liebesspiel zwischen Jean und mir: seine maskulinen schwarzen Maschinen attackieren meine bunten heiteren Skulpturen. Es war ein Kampf – ein Liebeskampf«[26]

Niki de Saint Phalle und Jean Tinguely begeisterten sich für das interaktive Spiel mit dem Publikum. Gemeinsam konzipierten sie einige Großplastiken mit Eventcharakter. Insgesamt acht Plakate sind Zeugnisse dieser fantastischen Gemeinschaftsprojekte, die 1966 mit der begehbaren Riesen-Nana *Hon* begannen. Das Plakat *(Taf. 1)* zur Ausstellung im Moderna Museet in Stockholm ist charakteristisch für den Stil Tinguelys, doch mit dem Motiv der Nana, deren Urheberin de Saint Phalle war, ist es besser als ihr gemeinsames Werk einzuordnen. Die Skizze umschreibt die Figur der Nana sowie die Konstruktion ihres Innenlebens. Pfeile und Treppenanlagen deuten die Führungslinie der Besucher an, die das anthropomorphe Gebäude durch ein Tor (Vagina) betraten. Quadrate verweisen auf verschiedene Räume, die auf dem Plakat mit Buchstaben gekennzeichnet sind. Bestimmt hat es großen Spaß gemacht, das Innenleben des weiblichen Gullivers zu entdecken: Darin befand sich u.a. ein Aquarium mit Goldfischen, ein Kino mit Greta-Garbo-Filmen, eine Galerie mit gefälschten Bildern à la Dubuffet und in den beiden Brüsten eine schummrige Bar und ein Planetarium. Den Besucherstrom regelten Verkehrsampeln, Hostessen boten kleine Erfrischungen an, und Plastiken von Tinguely und Per Olov Ultvedt gaben Geräusche von sich, die sich mit Bach'scher Orgelmusik mischten. *Hon* wurde eine große Publikumsattraktion: In nur drei Monaten kamen über 100000 Besucher, um dieses ›Gesamtkunstwerk‹ zu bestaunen, das ein heiterer Affront gegen das Tabuisieren von Sexualität war.

Schon ein Jahr später erhielten Tinguely und de Saint Phalle einen bedeutenden Skulpturenauftrag für die Weltausstellung in Montréal. Auf dem Dach des französischen Pavillons inszenierten sie ihr *Fantastisches Paradies*, ein kontrastreiches Ensemble aus farbenfrohen Nanas und Fantasie-Tieren, die von den schwarzbemalten Maschinen Tinguelys attackiert werden. Mit ihren unterschiedlichen Stilen, die sich als Gegensätze des Maskulinen und Femininen präsentieren, stellten die Künstler auf humorvolle Weise einen Geschlechterkampf dar. Die beiden Plakate für die Albright Knox Gallery und für das Moderna Museet *(Taf. 2, 3)* belegen die weitere Wirkungsgeschichte der großen Installation, die 1971 in Stockholm ihren endgültigen Standort fand. Zuvor war sie in Buffalo und sogar ein ganzes Jahr im New Yorker Central Park gezeigt worden. Der Anklang beim Publikum war überall

ouvrier du bâtiment ne trouve sa solution que plusieurs semaines plus tard avec le collage « all over » de la cinquième version de l'affiche – il s'agit d'une affiche publicitaire pour la saison du théâtre de Bâle *(pl. 44 a–e)*. Et en référence à ses modèles dadaïstes, Tinguely annonce sur une affiche vert poison la reprise du célèbre scandale théâtral de Tristan Tzara, *Le cœur à gaz*, avec le collage plein d'humour des lettres « Dani Dada Tzara Dasga… » *(pl. 38)*.

« Le Paradis fantastique était en fait un jeu amoureux entre Jean et moi : ses machines noires masculines attaquaient mes sculptures joyeuses et bigarrées. C'était un combat, combat amoureux[26] »

Niki de Saint Phalle et Jean Tinguely se passionnaient pour le jeu interactif avec le public. Ils conçurent ensemble quelques grandes sculptures à caractère événementiel. Au total, huit affiches montrent ces projets communs fantastiques, qui ont commencé en 1966 avec la nana géante *Hon* sur laquelle on pouvait marcher. L'affiche *(pl. 1)* de l'exposition au Moderna Museet de Stockholm est caractéristique du style de Tinguely, mais en raison du motif de la nana qui appartient à Niki de Saint Phalle, il convient de la classer parmi leurs œuvres communes. L'esquisse décrit la silhouette de la nana ainsi que l'architecture de sa vie intérieure. Les flèches et les escaliers indiquent le passage aux visiteurs qui pénètre dans le bâtiment anthropomorphe par une porte (le vagin). Des carrés définissent plusieurs espaces qui sont signalés sur l'affiche par des lettres. Il est certain que la découverte de la vie intérieure du Gulliver féminin ne s'est pas faite sans plaisir. À l'intérieur se trouvaient entre autres un aquarium avec des poissons rouges, un cinéma diffusant des films de Greta Garbo, une galerie avec des faux tableaux à la Dubuffet et, dans les deux seins, un bar plongé dans la pénombre ainsi qu'un planétarium. Le flux des visiteurs était réglé par des feux de signalisation, des hôtesses offraient des rafraîchissements et le bruit des sculptures de Tinguely et Per Olov Ultvedt retentissait en se mêlant à la musique pour orgue de Bach. *Hon* connut un grand succès auprès du public : en seulement trois mois, plus de 100 000 visiteurs vinrent admirer cette « œuvre d'art totale » qui était un joyeux affront au caractère tabou de la sexualité.

À peine un an plus tard, Jean Tinguely et Niki de Saint Phalle reçurent une commande importante pour l'Exposition universelle à Montréal. Sur le toit du pavillon français, ils exposèrent leur *Paradis fantastique*, un ensemble très contrasté de nanas joyeusement bigarrées et

In venerating our common divinity, we managed to forge an unusual relationship.'[29] It is difficult to take in how many projects each of them took on.

Undoubtedly no less entertaining than *Hon* and *Paradis Fantastique* was the huge dragon sculpture *Le Crocodrome (pl. 4)*, a joint work they did with their friends Bernhard Luginbühl and Daniel Spoerri. The sculpture was equipped with a ghost train and other fairground effects to celebrate the opening of the Pompidou Centre in Paris. The poster inviting the public to visit it shows clearly the montage of serpent and dragon motifs. Niki had got a printer to produce stickers of her own motifs specially for use in her correspondence, so here she was recycling her own creations.

For the Stravinsky Fountain poster *(pl. 5)* Tinguely and Saint Phalle used one of their printed works and montaged the individual motifs of the water effects into a new composition. In this example too, the edges of the stickers are clearly visible. The fountain in the square between the Pompidou Centre and the church of Saint-Merri became their most popular joint work. The City of Paris originally commissioned the work from Tinguely alone, but he insisted on doing it jointly with his partner. The tribute to the composer could not have turned out more fascinatingly. The sculptures of *Ragtime*, *Firebird* and *Nightingale* respond to Stravinsky's famous similarly named compositions with rhythmic movements, water spouts and contrasting colors.

'All power to the Nanas'[30]

No twentieth-century female artist is better known than Niki de Saint Phalle. Her Nanas made her famous overnight. They are probably the most popular trademark a female artist has ever developed. With their happy, faceless shapes they are an ideal projection surface. They are capable of addressing all ages and social classes alike.[31] Saint Phalle first made a name for herself some years earlier with her shooting actions—she was so to speak a 'shooting star'! But this aspect of her work soon faded into the background like many other things she did.

For Niki de Saint Phalle, art was an existential expression of her ambivalent attitude to life—it was self-therapy, a way of finding herself. How she saw her contribution to art and her viewpoint as part of art history is very illuminating: 'Niki is a special case, an outsider. Most sculptures by her have something timeless about them, and evoke memories of old cultures and dreams. Her work and her life are like stories full of adventures, evil dragons,

groß. Niki nannte die Skulpturengruppe ihr »Liebesspiel«[27] oder ihren »Liebeskampf«[28] mit Jean. Ihre gemeinsame Liebe zur Kunst sollte ihre Liebesbeziehung überdauern. Niki resümierte später: »Jean – die große Liebe deines Lebens war auf jeden Fall deine Arbeit, und für mich galt und gilt das gleiche. In Verehrung unserer gemeinsamen Gottheit gelang es uns, eine außergewöhnliche Beziehung zu schmieden.«[29] Es ist kaum fassbar, wieviel Projekte jeder von ihnen realisiert hat.

Nicht minder unterhaltsam als *Hon* und das *Fantastische Paradies* war sicher auch die riesige Drachenplastik *Le Crocrodrome (Taf. 4)*, ein Gemeinschaftswerk des Künstlerpaares, das sie mit ihren Freunden Bernhard Luginbühl und Daniel Spoerri ausführten. Die Plastik war mit einer Geisterbahn und anderen Jahrmarktseffekten ausgestattet, um die Eröffnung des Centre Georges Pompidou in Paris zu feiern. Auf dem Plakat, das zum Besuch einlädt, sieht man deutlich, dass die beiden kleinen Motive Schlange und Drache montiert wurden. Niki hatte sich insbesondere im Hinblick auf ihre Korrespondenz in einer Druckerei Aufkleber von ihren eigenen Motiven herstellen lassen. Sie recyclete also ihre eigenen Kreationen.

Für das Plakat zum *Stravinsky-Brunnen (Taf. 5)* verwendeten Tinguely und de Saint Phalle eine ihrer Druckgrafiken und montierten die einzelnen Motive der Wasserspiele zu einer neuen Komposition. Auch in diesem Beispiel sieht man die Umrandungen der Aufkleber ganz deutlich. Der Brunnen auf dem Platz zwischen dem Centre Georges Pompidou und der Kirche Saint Merri wurde ihr populärstes Gemeinschaftswerk. Den Auftrag hatte die Stadt Paris zunächst nur an Tinguely vergeben. Doch er wollte ihn partout nur gemeinsam mit seiner Partnerin annehmen. Die Hommage an den Komponisten hätte nicht faszinierender ausfallen können: Die Plastiken *Ragtime*, *Feuervogel* und *Nachtigall* antworten mit rhythmischen Bewegungen, Wasserspritzern und kontrastreichen Farben auf Stravinskys berühmte Kompositionen, deren Titel sie tragen.

»Alle Macht den Nanas«[30]

Keine Künstlerin des 20. Jahrhunderts hat einen größeren Bekanntheitsgrad erreicht als Niki de Saint Phalle. Ihre Nanas machten sie über Nacht berühmt. Sie sind das wohl populärste Markenzeichen, das eine Künstlerin je entwickelt hat: Mit ihrem fröhlichen gesichtslosen Erscheinungsbild sind sie eine ideale Projektionsfläche. Sie vermögen »unterschiedlichste Altersstufen und soziale Schichten gleichermaßen anzusprechen«[31]. Mit spektakulären Schießhappenings hatte de Saint Phalle einige Jahre zuvor schon ein erstes Mal Aufsehen erregt – sie war im

d'animaux imaginaires attaqués par les machines peintes en noir de Tinguely. Avec leurs styles différents, qui illustrent l'opposition masculin-féminin, les artistes représentent avec beaucoup d'humour le combat des sexes. Les deux affiches pour la Albright Knox Gallery et pour le Moderna Museet *(pl. 2, 3)* documentent l'avenir de la grande installation qui trouva sa place définitive à Stockholm en 1971. Elle fut auparavant exposée à Buffalo et même toute une année au Central Park de New York. Le retentissement auprès du public a partout été très important. Niki surnommait le groupe de sculpture son «jeu amoureux[27]» ou encore son «combat amoureux[28]» avec Jean. Leur amour commun pour l'art allait résister à leur relation amoureuse. Niki résumera plus tard : «Jean – le grand amour de ta vie était de toute façon ton travail, et pour moi, c'était et c'est la même chose. Dans l'adoration de notre idole, nous sommes parvenus à forger une relation exceptionnelle[29]. » On a du mal à se représenter la quantité de projets que chacun d'entre eux a réalisés.

Non moins divertissant que *Hon* ou le *Paradis fantastique*, *Le Crocrodrome (pl. 4)*, sculpture géante d'un dragon, est l'œuvre commune du couple, exécutée avec leurs amis Bernhard Luginbühl et Daniel Spoerri. La statue était équipée d'un train fantôme et autres éléments de kermesse pour fêter l'ouverture du Centre Georges Pompidou à Paris. Sur l'affiche invitant à la visite, on voit clairement que les deux petits motifs du serpent et du dragon ont été montés. Niki s'était fait fabriquer des autocollants avec ses propres motifs, en particulier pour sa correspondance. Elle recyclait ainsi ses propres créations.

Pour l'affiche de la *Fontaine Stravinsky (pl. 5)*, Jean Tinguely et Niki de Saint Phalle utilisèrent l'un de leurs dessins imprimés et firent une nouvelle composition pour chacun des motifs des jeux d'eau. Toujours dans cet exemple, on voit nettement les contours formés par les autocollants. La fontaine, située sur la place entre le Centre Georges Pompidou et l'église Saint-Merri, est devenue leur œuvre commune la pus connue. Au début, la Ville de Paris n'avait passé commande qu'auprès de Tinguely. Mais celui-ci ne voulait l'accepter qu'avec sa partenaire. L'hommage au compositeur n'aurait pu être plus fascinant : les sculptures *Ragtime*, *Oiseau de feu* et *Rossignol* font échos aux célèbres compositions de Stravinsky dont elles portent les titres avec des mouvements rythmiques, des jets d'eau et des couleurs très contrastées.

hidden treasures full of man-eating mothers and witches. Birds of paradise occur in them, as do good mothers, intimations of heaven and the descent into hell. The same themes constantly recur in various forms, colors and materials. Myths and symbols have been periodically re-invented and recreated in all ages and cultures. Niki shows us in her wholly modern art that these myths and symbols are still alive. The Nanas for example are wholly sculptures of our time—but in the case of some of them you immediately think of the Willendorf Venus.'[32]

The posters reflect the above repertory of motifs. The earliest ones date from when Niki was already living with Jean. Through him and their Nouveau Réaliste friends she found in an environment she could take her art out into instead of sitting in isolation with her self-therapy. The first item in our catalogue of works is presumably the first she did anywhere since it promotes her first solo exhibition at the Hanover Gallery in London, in 1964 (pl. 6). The dragon shown on it, whose body she has studded with bits of collage material, is typical of her work at the time—dragons and monsters, witches, hearts, brides and child-bearing mothers are the principal motifs, on the surfaces of which she accumulates a profusion of plastic toys. The reliefs that these produced subsequently became some of the targets for her shooting actions.

One year later she exhibited her new Nana inventions for the first time. Initially they were made of fabric or canvas. As the poster for the Iolas gallery shows (pl. 7), they were not particularly colorful at this stage but painted in rather muted tones. Then in 1966 she and Tinguely did the huge *Hon* Nana for the Moderna Museet (pl. 1), whose success was a turning point for her subsequent career. In the same year, she did the stage sets for a performance of *Lysistrata* by Aristophanes at the Staatstheater in Kassel (cat. 11), and in 1967 had her first retrospective at the Stedelijk Museum in Amsterdam (pl. 8). A now self-assured Niki wrote 'All power to the Nanas' on the poster, anticipating the women's movement. For her posters in the mid-1960s she used mainly bright colors, even to the point of favouring fluorescent tones, and for a short time came aesthetically within the orbit of Pop Art. The brilliance was enhanced by the use of color backgrounds. The Nanas were for her a 'symbol of a happy, liberated woman.'[33] They were the result of her managing to shake off the traumatic experiences of her childhood. 'Suddenly the pain was over, I stood there and made figures of joy. I'd set off on a new career and begun a new chapter called Nanas. They

wahrsten Sinne des Wortes ein »shooting star«. Doch dieser Aspekt ihres Werkes geriet bald wieder in Vergessenheit wie soviele andere ihrer Facetten.

Für Niki de Saint Phalle war Kunst existenzieller Ausdruck ihres sehr ambivalenten Lebensgefühls – mit Hilfe der Kunst therapierte sie sich selbst und fand zu ihrer Identität. Sehr aufschlussreich ist, wie sie ihren künstlerischen Beitrag und ihren Standpunkt innerhalb der Kunstgeschichte einschätzte: »Niki ist ein besonderer Fall, ein Außenseiter. Die meisten Plastiken Nikis haben etwas Zeitloses, sind Erinnerungen an alte Kulturen und Träume. Ihr Werk und ihr Leben sind wie Märchen: voller Abenteuer, böser Drachen, versteckter Schätze, voll menschenfressender Mütter und Hexen. Paradiesvögel kommen darin ebenso vor wie gute Mütter, Ahnungen des Himmels ebenso wie der Abstieg in die Hölle. In verschiedenen Formen, Farben und Materialien treten immer wieder dieselben Themen auf. Durch alle Zeiten und Kulturen hindurch sind Mythen und Symbole periodisch wiedererfunden und neuerschaffen worden. Niki zeigt uns auf ihre ganz moderne Art, dass diese Mythen und Symbole noch immer lebendig sind. So sind zum Beispiel die Nanas ganz Plastiken aus unserer Zeit – und doch muss man bei einigen sofort an die Venus von Willendorf denken.«[32]

Das Plakatwerk spiegelt das angesprochene motivische Repertoire wider. Es setzt ein, als Niki bereits mit Jean zusammenlebt. Durch ihn und im Freundeskreis der ›Nouveaux Réalistes‹ fand sie das Milieu, um mit ihrer Kunst nach außen zu gehen, anstelle sich mit Selbsttherapie in Isolation zu begeben. Das erste Plakat unseres Werkverzeichnisses ist vermutlich das erste überhaupt, das sie gestaltet hat, bewirbt es doch ihre erste bedeutende Einzelausstellung in der Hanover Gallery in London 1964 (Taf. 6). Der darauf abgebildete Drache, dessen Körper sie mit zahlreichem Collagematerial übersät hat, ist charakteristisch für ihr damaliges Werk: Drachen und Monster, Hexen, Herzen, Bräute und Gebärende sind ihre Hauptmotive, an deren Oberflächen sie eine Überfülle an Plastikspielzeug akkumulierte. Die so entstandenen Reliefs dienten ihr auch als Zielscheibe für ihre Schießhappenings.

Ein Jahr später stellte Niki de Saint Phalle zum ersten Mal ihre neuen Erfindungen – die Nanas – aus. Anfangs bestanden sie aus Stoff oder Leinwand. Wie das Plakat für die Galerie Iolas zeigt (Taf. 7), waren sie noch nicht so farbenfroh, sondern in eher gedeckten Tönen in der Art eines Patchworks bemalt. Gemeinsam mit Tinguely konnte sie 1966 im Moderna Museet eine Riesen-Nana verwirklichen (Taf. 1) – mit bahnbrechendem Erfolg für ihre weitere Karriere: Noch im gleichen Jahr gestaltete sie das Bühnenbild für die Aufführung von Aristophanes' *Lysistrata*

« Tout le pouvoir aux nanas[30] »

Aucune autre artiste femme du XXe siècle n'est plus célèbre que Niki de Saint Phalle. Ses nanas ont fait sa réputation du jour au lendemain. C'est certainement le label d'artiste le plus populaire qu'une artiste a jamais créé : avec leur silhouette joyeuse et sans visage, elles constituent une surface idéale de projection. Elles sont capables «d'interpeller de la même manière les groupes d'âge et les couches sociales les plus divers[31]». Quelques années auparavant, avec ses actions-tirs spectaculaires, Niki de Saint Phalle était déjà reconnue – elle était au sens propre du terme une « shooting star ». Mais cet aspect de son œuvre tomba rapidement dans l'oubli, comme beaucoup d'autres. Pour Niki de Saint Phalle, l'art est l'expression existentielle de son sentiment ambivalent par rapport à la vie – par le truchement de l'art, elle s'est soignée et a trouvé son identité. Il est très intéressant, du reste, de voir comment elle considérait sa contribution au monde de l'art et sa position dans l'histoire de l'art : «Niki est un cas particulier, une personne à part. La plupart des sculptures de Niki ont quelque chose qui dépasse le temps, elles sont des souvenirs d'anciennes cultures et de vieux rêves. Son œuvre et sa vie sont comme un conte : plein d'aventures, de méchants dragons, de trésors cachés, de mères et de sorcières dévoreuses d'enfants. Les oiseaux de paradis y sont autant présents que les bonnes mères, les présages du ciel autant que la chute en enfer. Les mêmes thèmes se manifestent sous différentes formes, couleurs ou matières. À toutes les époques et dans toutes les cultures, les mythes et les symboles ont été périodiquement redécouverts et recréés. Niki nous montre de manière tout à fait moderne que ces mythes et symboles sont toujours vivants. Ainsi, par exemple, les nanas sont tout à fait des sculptures de notre temps – et pourtant, à la vue de certaines, on pense tout de suite à la Vénus de Willendorf[32]. »

Les affiches reflètent le répertoire de motifs évoqués. Il commence alors que Niki vivait déjà avec Jean. Grâce à lui et au cercle d'amis des « Nouveaux Réalistes », elle trouve le milieu favorable pour porter son art vers l'extérieur plutôt que de s'adonner à l'auto-thérapie dans l'isolation. La première affiche de notre registre des œuvres est peut-être la première qu'elle a jamais composée, mais fait pourtant la publicité de sa première exposition personnelle à la Hanover Gallery à Londres en 1964 (pl. 6). Le dragon qui y est représenté, dont le corps est saturé d'éléments collés, est typique de son œuvre de cette époque : des dragons et des monstres, des sorcières, des cœurs, des mariées et des femmes en train d'accoucher sont les principaux motifs sur lesquels elle accumule

were very happy creatures without pain, they danced in a world of music, sound and joy.'[34]

The Nanas were a very popular motif. In 1966, Niki did several for the ballet performance of Roland Petit's *Eloge de la Folie*, where the dancers playfully involved them in the choreography. In 1970, a Nana poster advertised productions by the famous Modern Dance choreographers Merce Cunningham and Paul Taylor at the Théâtre de France in Paris *(cat. 21)*. Three large Nanas were bought by the city of Hanover and set up on the Leine embankment. Niki de Saint Phalle often used Nanas as advertising motifs, for example in the poster she did for the Jazz Festival in Montréal *(pl. 20)*, in which a black Nana exhilarated by jazz appears against a mystic blue background. Or in a very similar pose in her poster advertising her own perfume creations, which helped to finance her long-dreamt-of project for a Tarot Garden *(pl. 22)*.

The poster for her film *Daddy (pl. 17)* alludes to the causes of her psychic problems, which she hoped to exorcise through the film: a blindfold male portrait (Daddy) thinks of a small girl. A Nana is seen rushing up. A brief comment comes between the two female figures: 'Niki's naughty erotic game against Daddy.' The poster has the effect of a matrix: Niki remembering sexual molestation by her father when she was still a child. Her Nanas seem immune to such attacks—they represent to some extent a positive alternative world. With her Nanas and her satirical film Niki found her way back to a positive outlook. Her art saved her from despair. Presumably these experiences were also the motivation for her strong support for children, e.g. in designing sculptural adventure spaces such as the dragon of *Golem* for a children's playground in Jerusalem *(pl. 14)*. The three red tongues function as slides.

Later on she summed things up a little more forgivingly: "The men in my life—those beasts—were my muses. For many years my art thrived on this suffering and my revenge."[35] Tinguely played a decisive role in helping de Saint Phalle turn many of her ideas, originally drafted in the form of a series of drawings, into sculptures. With his assistance she created her architectonic ensembles, imitating the style of Antoni Gaudí and Facteur Cheval. Tinguely was not put off by the time and trouble involved, constructing instead the load-bearing metal skeletons for de Saint Phalle's sculptures. With a wry smile, Tinguely described himself as Niki's "technical assistant"[36] and, without his support, her monumental Tarot Garden would probably never have come about. The unique relationship between Jean

im Staatstheater Kassel *(Cat. 11)*, und 1967 wurde im Stedelijk Museum in Amsterdam ihre erste Retrospektive gezeigt *(Taf. 8)*. Selbstbewusst titelt Niki auf dem Plakat »Alle Macht den Nanas« und greift somit der Frauenbewegung vor. Für ihre Plakate Mitte der 60er Jahre verwendet sie vorwiegend leuchtende Farben, gerne auch in Neonoptik und gerät für kurze Zeit ästhetisch in die Nähe der Pop Art. Durch die Verwendung farbiger Fonds wird die Leuchtkraft noch gesteigert. Die Nanas waren für sie »das Symbol einer fröhlichen, befreiten Frau«[33], das Ergebnis ihres ganz persönlichen Befreiungsschlags gegen traumatische Erlebnisse der Kindheit: »Plötzlich war der Schmerz vorüber, ich stand da und machte Figuren der Freude. Ich hatte einen neuen Weg eingeschlagen, ein neues Kapitel begonnen und das hieß Nanas. Sie waren sehr fröhliche Geschöpfe ohne Schmerz, sie tanzten in einer Welt aus Musik, aus Klang, aus Freude.«[34]

Die Nanas waren ein sehr beliebtes Motiv: 1966 entstanden mehrere für die Balettaufführung von Roland Petits *Eloge de la Folie*, die von den Tänzern spielerisch in die Choreografie eingebunden wurden. 1970 warb ein Nanaplakat *(Cat. 21)* für die Aufführungen der berühmten Choreografen des Modern Dance, Merce Cunningham und Paul Taylor, im Théâtre de France in Paris. Drei große Nanas wurden 1974 von der Stadt Hannover angekauft und am Leineufer aufgestellt. Niki de Saint Phalle setzte sie häufig als Werbemotiv ein, zum Beispiel für ihren Plakatbeitrag zum Jazz Festival in Montréal *(Taf. 20)*, bei dem eine schwarze Nana auf mystisch blauem Fond sich vom Jazz beschwingt zeigt. Oder in ganz ähnlicher Pose auf ihrem Werbeplakat für eigene Parfumkreationen, mit denen sie ihren Lebenstraum, das Projekt des *Tarotgartens* finanzierte *(Taf. 22)*.

Das Plakat zu ihrem Film *Daddy (Taf. 17)* spielt auf die Ursache ihrer psychischen Probleme an, die sie mit diesem Film zu verarbeiten hoffte: ein Männerporträt (Daddy) mit verbundenen Augen denkt an ein kleines Mädchen. Eine Nana eilt herbei. Zwischen den beiden weiblichen Figuren steht ein kurzer Kommentar: »Nikis böses erotisches Spiel gegen Daddy«. Das Plakat wirkt wie eine Matrix: Niki erinnert sich an die sexuellen Übergriffe ihres Vaters, als sie noch ein Kind war. Ihre Nanas scheinen gegen derlei Attacken immun – sie verkörpern gewissermaßen die positive Gegenwelt. Niki de Saint Phalle hat sich mit ihren Nanas und mit ihrer Filmsatire eine positive Lebenseinstellung zurückerobert. Ihre Kunst rettete sie vor der Verzweiflung. Vermutlich auch aus diesen Erfahrungen setzte sie sich besonders für Kinder ein und gestaltete für sie plastische Erlebnisräume wie den Drachen *Golem* für einen Kinderspielplatz in Jerusalem

une quantité énorme de jouets en plastique. Les reliefs ainsi obtenus lui servaient également de cibles pour ses actions-tirs.

Un an plus tard, Niki de Saint Phalle expose pour la première fois ses nouvelles inventions – les nanas. Au début, elles étaient réalisées en tissu ou en toile. Comme l'affiche pour la galerie Iolas le montre *(pl. 7)*, elles n'avaient pas encore tant de couleurs vives, elles étaient plutôt peintes dans des tons atténués à la manière d'un patchwork. Avec Tinguely, elle put réaliser en 1966 une nana géante *(pl. 1)* au Moderna Museet – remportant un succès déterminant pour sa future carrière : la même année, elle réalisa les décors pour la représentation de *Lysistrata* d'Aristophane au Staatstheater de Kassel *(cat. 11)* et, en 1967, sa première grande rétrospective fut organisée au Stedelijk Museum d'Amsterdam *(pl. 8)*. En toute conscience, Niki titre sur l'affiche « Tout le pouvoir aux nanas » et devance ainsi le mouvement féministe. Dans ses affiches du milieu des années 1960, elle utilise principalement des couleurs lumineuses, joue volontiers sur les effets optiques et, pendant une brève période, se rapproche de l'esthétique du Pop Art. La luminosité est encore accentuée par l'utilisation de fonds colorés. Selon elle, les nanas sont « le symbole de la femme joyeuse et libre[33] ». Elles sont le résultat de son propre affranchissement de ses expériences traumatiques dans l'enfance : « Soudain, la douleur avait disparu, j'étais là et je fabriquais des figures de la joie. J'avais pris un nouveau chemin, commencé un nouveau chapitre qui s'appelait nana. C'était des créatures très joyeuses, sans douleur, elles dansaient dans un univers de musique, de sons et de joie[34]. »

Les nanas sont un motif très apprécié : en 1966, plusieurs voient le jour à l'occasion de la représentation du ballet de Roland Petit *Éloge de la folie*, où les danseurs les intègrent de manière ludique dans la chorégraphie. En 1970, une affiche nana fait la publicité des représentations des célèbres chorégraphes du Modern Dance, Merce Cunningham et Paul Taylor, au Théâtre de France à Paris *(cat. 21)*. En 1974, la ville de Hanovre achète trois grandes nanas pour les exposer sur le Leineufer. Niki de Saint Phalle les utilisaient également souvent comme motif publicitaire, par exemple pour son affiche du Festival de Jazz de Montréal *(pl. 20)*, sur laquelle on peut voir le jazz faisant swinguer une nana noire sur fond bleu mystique. Ou encore, dans une pose tout à fait identique, sur l'affiche de la ligne de parfums qu'elle avait créée et avec laquelle elle finança le rêve de sa vie, le projet du *Jardin du Tarot (pl. 22)*.

L'affiche de son film *Daddy (pl. 17)* fait allusion à l'origine de ses problèmes psychiques

Tinguely and Niki de Saint Phalle continued even after the former's death. Thanks to Niki's commitment and a generous gift of Tinguely's major works from the artist's bequest, it was possible to found the Museum Jean Tinguely in his home town of Basle. Similarly, de Saint Phalle presented a number of her own important works to the Sprengel Museum in Hanover and the Musée d'Art Moderne et d'Art Contemporain in Nice. The last two posters she worked on *(pl. 29, 30)* perfectly illustrate the artist's exceptional commitment in establishing permanent exhibitions of her own œuvre and that of Tinguely.

(Taf. 14). Die drei roten Zungen dienen als Rutschbahnen.

Später resümierte sie versöhnlich: »Die Männer in meinem Leben, diese Bestien, waren meine Musen. Das Leiden und meine Rache an ihnen – davon zehrte viele Jahre meine Kunst.«[35] Tinguely trug entscheidend dazu bei, dass de Saint Phalle viele ihrer Ideen, die sie in gezeichneten Bildgeschichten entwickelt hatte, als Plastiken realisieren konnte: Mit seiner Hilfe entwickelte sie architektonische Ensembles, darin ihren Vorbildern Antoni Gaudí und Facteur Cheval nacheifernd. Tinguely scheute weder Mühe noch Aufwand und konstruierte für sie die tragenden Metallskelette. Mit einem Augenzwinkern bezeichnete er sich einmal als Nikis »Hilfstechniker«[36] – ohne seine Unterstützung wäre ihr monumentaler Tarotgarten vielleicht nie entstanden. Die einzigartige Beziehung zwischen Jean Tinguely und Niki de Saint Phalle währte über dessen Tod hinaus. Durch Nikis Engagement und ihre großzügige Schenkung von Hauptwerken aus seinem Nachlass wurde das Museum Jean Tinguely in seiner Heimatstadt Basel möglich. Desgleichen stiftete sie bedeutende eigene Werke an das Sprengel Museum in Hannover und das Musée d'Art moderne et d'Art contemporain in Nizza. Ihre beiden letzten Plakate *(Taf. 29, 30)* zeugen bilderreich von diesem großartigen Engagement, mit dem sie die dauerhafte Präsentation ihrer beider Œuvres sicherstellte.

qu'elle espérait dépasser avec ce film : un portrait d'homme (Daddy) aux yeux bandés pense à une fillette. Une nana arrive avec empressement. Entre les deux personnages féminins se trouve un commentaire laconique : « Le cruel jeu érotique de Niki contre Daddy ». L'affiche fait l'effet d'une matrice : Niki se souvient des violences sexuelles que son père lui a infligées lorsqu'elle était enfant. Ses nanas semblent immunisées contre de telles attaques – elles incarnent en quelque sorte la partie positive du monde. Niki de Saint Phalle a reconquis, avec ses nanas et sa satire filmique, une relation positive à la vie. Son art l'a sauvée du désespoir. C'est certainement aussi à cause de cette expérience qu'elle s'engagea particulièrement pour les enfants et créa pour eux des espaces d'expérience plastique comme le dragon *Golem* pour une aire de jeu à Jérusalem *(pl. 14)*. Les trois langues rouges servent de toboggan.

Plus tard, elle résumera en guise de réconciliation : « Dans ma vie, les hommes, ces monstres, ont été muses. La souffrance qu'ils m'ont causée, mon besoin de vengeance, a nourri mon art pendant des années[35]. » Tinguely a considérablement contribué à la soutenir dans la réalisation des idées qu'elle développait sous forme de dessins. Elle élabora ainsi des constructions inspirées de ses modèles Antoni Gaudí et le Facteur Cheval. Ne reculant devant aucun effort, Tinguely a fabriqué pour elle d'imposants squelettes de métal. Il s'est d'ailleurs un jour qualifié lui-même, en plaisantant, d'« assistant technique[36] » de Niki. Sans son soutien, son gigantesque Jardin du Tarot n'aurait sans doute jamais vu le jour. La relation très particulière qui a uni Niki de Saint Phalle et Jean Tinguely a perduré au-delà de la mort de celui-ci. C'est grâce à l'engagement de Niki et à sa généreuse donation qu'a pu être fondé le Musée Tinguely à Bâle, la ville natale de l'artiste. Elle a donné également de ses propres œuvres au Sprengel Museum de Hanovre et au Musée de Nice. Ses deux dernières affiches *(pl. 29, 30)* sont la preuve de ce formidable engagement – lequel garantit également la présentation durable des œuvres des deux artistes.

1 Niki de Saint Phalle, in: *Jean Tinguely Basel. Die Sammlung*, exhib. cat. Museum Jean Tinguely, Basle/Berne 1996, p. 17.

2 Peter Schamoni in conversation with the present writer, May 2005.

3 A frequently cited phrase attributed to Werner Haftmann, cf. idem, *Painting in the 20th Century*, vol. 2, Munich 1961, 6th edition 1980, p. 325 ff.

4 Pierre Restany, 'Die Nouveaux Réalistes, 1. Manifest, Milan 1960', in Jean-Louis Ferrier (ed.), *Dumont's Chronik der Kunst im 20. Jahrhundert*, Cologne 1990, p. 569.

5 Jean Tinguely, in Margrit Hahnloser (ed.), *Briefe von Jean Tinguely an Maja Sacher*, Berne 1992, p. 16.

6 Hanns U. Christen, in *Basler Bilderbogen*, no. 4, 1962, p. 15.

7 Cf. Jean Tinguely, in Eduard Trier, *Bildhauertheorien im 20. Jahrhundert*, 4th edition, Berlin 1992, p. 221.

8 Many of the early sketches have not survived, as Tinguely considered them to be purely working sketches and generally threw them away when the sculpture was finished. However, the Jean Tinguely Museum in Basle does have some of the drawings that have survived in its collection.

9 Jean Tinguely, *Catalogue Raisonné, Skulpturen und Reliefs 1954–1968 [CR]*, Edition Galerie Bischofberger, Küsnacht/Zurich 1982, and *Catalogue Raisonné*, vol. 2, *Skulpturen und Reliefs 1969–1985*, Edition Galerie Bischofberger, Küsnacht/Zurich 1990. As a catalogue of Tinguely's drawings has still to be produced, attribution was facilitated by the following exhib. cat.: *Jean Tinguely, Dessins et gravures pour les sculptures*, Cabinet des estampes, Musée d'art et d'histoire, Geneva 1976.

10 Cf. CR (see note 9), nos 359, 430, 451, 489; cf. exhib. cat. Geneva (see note 9), nos 192, 227–31.

11 Cf. CR, nos 176, 388, 456; cf. exhib. cat. Geneva (see note 9), nos 58, 80.

12 Cf. CR, nos 397–400.

13 Cf. CR, nos 230, 231, 233.

14 Cf. CR, no. 395.

15 Cf. CR, no. 371.

16 Cf. CR, no. 187.

17 Cf. CR, no. 442.

18 Cf. CR, no. 347, cf. exhib. cat. Geneva (see note 9), nos 35–37.

19 Cf. exhib. cat. *Jeannot an Franz, Briefe und Zeichnungen von Jean Tinguely an Franz Meyer*, Museum Jean Tinguely, Berne 2003.

20 Cf. Guido Magnaguagno, in: *Tinguely in Ingelheim. Das Abc einer wundersamen Welt*, exhib. cat. Internationale Tage, Ingelheim 2005, n.p.

21 Cf. CR, no. 495; cf. exhib. cat. Geneva (see note 9), no. 232–303, 361–63.

22 Cf. *Jeannot an Franz...* (see note 19), p. 12.

23 Isidor Lucien Ducasse Lautréamont, *Chants de Maldoror*, 1870, quoted from Susanna Partsch, *Kunst-Epochen im 20. Jahrhundert*, vol. 2, Stuttgart 2002.

24 Jean Tinguely, in: Hahnloser 1992 (see note 5), p. 16.

25 Jean Tinguely, in: *Briefe* (see note 5), p. 18.

26 Niki de Saint Phalle in Peter Schamoni's film *Niki de Saint Phalle. Wer ist das Monster, du oder ich?*, Munich 1994.

27 Loc. cit.

28 Loc. cit.

29 Niki de Saint Phalle, in: *Jean Tinguely...* (see note 1), p. 30.

30 Niki de Saint Phalle on her exhibition poster for the Stedelijk Museum, Amsterdam 1967.

31 Niki de Saint Phalle, in: Carla Schulz-Hoffmann (ed.), *Niki de Saint Phalle, Bilder – Figuren – Phantastische Gärten*, exhib. cat. Kunsthalle der Hypo-Kulturstiftung, Munich 1987, reprinted Munich 1997, foreword.

32 Op. cit., p. 39.

33 Op. cit., p. 20.

34 Niki de Saint Phalle in the film by Peter Schamoni (see note 26), Munich 1994.

35 Op. cit.

36 Op. cit.

1 Niki de Saint Phalle, in: *Jean Tinguely Basel. Die Sammlung*, Ausst.-Cat. Museum Jean Tinguely, Basel, Bern 1996, S. 17.

2 Peter Schamoni im Gespräch mit der Autorin, Mai 2005.

3 Der häufig zitierte Begriff stammt von Werner Haftmann, vgl. ders., *Malerei im 20. Jahrhundert*, Band 2, München 1965, 5. Aufl. 1987, S. 325 ff.

4 *Pierre Restany: die Nouveaux Réalistes, 1. Manifest*, Mailand 1960, in: Jean-Louis Ferrier (Hrsg.), *Dumont's Chronik der Kunst im 20. Jahrhundert*, Köln 1990, S. 569.

5 Jean Tinguely, in: Margrit Hahnloser (Hrsg.), *Briefe von Jean Tinguely an Maja Sacher*, Bern 1992, S. 16.

6 Hanns U. Christen, in: *Basler Bilderbogen*, Nr. 4, 1962, S. 15.

7 Vgl. Jean Tinguely, in: Eduard Trier, *Bildhauertheorien im 20. Jahrhundert*, 4. Aufl., Berlin 1992, S. 221.

8 Viele der frühen Skizzen haben sich nicht erhalten, da sie Tinguely als reine Arbeitsskizzen betrachtete und sie nach der Fertigstellung einer Plastik meistens wegwarf. Das Museum Jean Tinguely in Basel bewahrt in seiner Sammlung einige dieser Zeichnungen auf.

9 Jean Tinguely, *Catalogue Raisonné, Skulpturen und Reliefs 1954–1968*, Edition Galerie Bischofberger, Küsnacht/Zürich 1982, sowie *Catalogue Raisonné*, Bd. 2, *Skulpturen und Reliefs 1969–1985*, Edition Galerie Bischofberger, Küsnacht/Zürich 1990. Da ein Œuvre-Katalog der Zeichnungen Tinguelys noch aussteht, ermöglichte folgender Ausst.-Cat. die Zuordnung: *Jean Tinguely, Dessins et gravures pour les sculptures*, Cabinet des estampes, Musée d'art et d'histoire, Genf 1976.

10 Vgl. WVZ (siehe Anm. 9), Nr. 359, 430, 451, 489; vgl. Ausst.-Cat. Genf (siehe Anm. 9), Nr. 192, 227–231.

11 Vgl. WVZ, Nr. 176, 388, 456; vgl. Ausst.-Cat. Genf (siehe Anm. 9), Nr. 58, 80.

12 Vgl. WVZ, Nr. 397–400.

13 Vgl. WVZ, Nr. 230, 231, 233.

14 Vgl. WVZ, Nr. 395.

15 Vgl. WVZ, Nr. 371.

16 Vgl. WVZ, Nr. 187.

17 Vgl. WVZ, Nr. 442.

18 Vgl. WVZ, Nr. 347, vgl. Ausst.-Cat. Genf (siehe Anm. 9), Nr. 35–57.

19 Vgl. Ausst.-Cat. *Jeannot an Franz, Briefe und Zeichnungen von Jean Tinguely an Franz Meyer*, Museum Jean Tinguely, Bern 2003.

20 Vgl. Guido Magnaguagno, in: *Tinguely in Ingelheim. Das Abc einer wundersamen Welt*, Ausst.-Cat. Internationale Tage Ingelheim 2005, o.S.

21 Vgl. WVZ, Nr. 495; vgl. Ausst.-Cat. Genf (siehe Anm. 9), Nr. 232–303, 361–363.

22 Vgl. *Jeannot an Franz...* (siehe Anm. 19), S. 12.

23 Isidor Lucien Ducasse Lautréamont, *Chants de Maldoror*, 1870, zitiert nach Susanna Partsch, *Kunst-Epochen im 20. Jahrhundert*, Bd. 2, Stuttgart 2002.

24 Sinngemäß: an die Stelle der Gefühle treten kann. Jean Tinguely, in: Hahnloser 1992 (siehe Anm. 5), S. 16.

25 Jean Tinguely, in: *Briefe* (siehe Anm. 5), S. 18.

26 Niki de Saint Phalle in Peter Schamonis Film *Niki de Saint Phalle. Wer ist das Monster, du oder ich?*, München 1994.

27 Ebenda.

28 Ebenda.

29 Niki de Saint Phalle, in: *Jean Tinguely...* (siehe Anm. 1), S. 30.

30 Niki de Saint Phalle auf ihrem Ausstellungsplakat des Stedelijk-Museums, Amsterdam 1967.

31 Niki de Saint Phalle, in: Carla Schulz-Hoffmann (Hrsg.), *Niki de Saint Phalle, Bilder – Figuren – Phantastische Gärten*, Ausst.-Cat. Kunsthalle der Hypo-Kulturstiftung, München 1987, Neuauflage München 1997, Vorwort.

32 Ebenda, S. 39.

33 Ebenda, S. 20.

34 Niki de Saint Phalle im Film von Peter Schamoni (siehe Anm. 26), München 1994.

35 Ebenda.

36 Ebenda.

1 Niki de Saint Phalle, in *Jean Tinguely Basel. Die Sammlung*, cat. d'expo. Museum Jean Tinguely, Bâle, Berne, 1996, p. 17

2 Peter Schamoni dans un entretien avec l'auteur, mai 2005

3 L'expression souvent citée provient de Werner Haftmann, cf. du même auteur, *Malerei im 20. Jahrhundert*, vol. 2, Munich, 1965, 5e édition 1987, p. 325 *sq.*

4 « Pierre Restany : die Nouveaux Réalistes, 1er manifeste », Milan, 1960, in Jean-Louis Ferrier (éd.), *Dumont's Chronik der Kunst im 20. Jahrhundert*, Cologne, 1990, p. 569

5 Jean Tinguely, in Margrit Hahnloser (éd.), *Briefe von Jean Tinguely an Maja Sacher*, Berne, 1992, p. 16

6 Hanns U. Christen, in *Basler Bilderbogen*, n° 4, 1962, p. 15

7 Cf. Jean Tinguely, in Eduard Trier, *Bildhauertheorien im 20. Jahrhundert*, 4e édition, Berlin, 1992, p. 221

8 Quantité d'esquisses n'ont pas été conservées, car Tinguely les considérait comme de pures esquisses de travail et les jetait la plupart du temps après la réalisation de la sculpture. Le Musée Jean Tinguely de Bâle conserve dans une collection quelques-uns de ces dessins.

9 Jean Tinguely, *Catalogue Raisonné, Skulpturen und Reliefs 1954–1968*, Édition Galerie Bischofberger, Küsnacht/Zurich, 1982, ainsi que *Catalogue Raisonné*, vol. 2, *Skulpturen und Reliefs 1969–1985*, Édition Galerie Bischofberger, Küsnacht/Zurich, 1990. Comme il n'existe pas encore de catalogue raisonné des dessins de Tinguely, le catalogue d'exposition suivant nous a permis d'établir les correspondances : *Jean Tinguely, Dessins et gravures pour les sculptures*, Cabinet des estampes, Musée d'art et d'histoire, Genève, 1976

10 Cf. WVZ (*op. cit.* note 9), n° 359, 430, 451, 489 ; cf. catalogue d'exposition Genève (*op. cit.* note 9), n° 192, 227–231

11 Cf. WVZ, n° 176, 388, 456 ; cf. Genève (*op. cit.* note 9), n° 58, 80

12 Cf. WVZ, n° 397–400

13 Cf. WVZ, n° 230, 231, 233

14 Cf. WVZ, n° 395

15 Cf. WVZ, n° 371

16 Cf. WVZ, n° 187

17 Cf. WVZ, n° 442

18 Cf. WVZ, n° 347 ; cf. Genève (*op. cit.* note 9), n° 35-57

19 Cf. Catalogue d'exposition *Jeannot an Franz, Briefe und Zeichnungen von Jean Tinguely an Franz Meyer*, Musée Jean Tinguely, Berne, 2003

20 Cf. Guido Magnaguagno, in *Tinguely in Ingelheim. Das Abc einer wundersamen Welt*, cat. d'expo. Internationale Tage Ingelheim, 2005

21 Cf. WVZ, n° 495 ; cf. Genève (*op. cit.* note 9), n° 232–303, 361–363

22 Cf. *Jeannot an Franz* (*op. cit.* note 19), p. 12

23 Isidor Lucien Ducasse Lautréamont, *Chants de Maldoror*, 1870, cité d'après Susanna Partsch, *Kunst-Epochen im 20. Jahrhundert*, vol. 2, Stuttgart, 2002

24 Jean Tinguely, in *Briefe* (*op. cit.* note 5), p. 16

25 *Ibidem*, p. 18

26 Niki de Saint Phalle dans le film de Peter Schamoni *Niki de Saint Phalle. Wer ist das Monster, du oder ich ?*, Munich, 1994

27 *Ibidem*

28 *Ibidem*

29 Niki de Saint Phalle, in *Jean Tinguely* (*op. cit.* note 1), p. 30

30 Niki de Saint Phalle sur l'affiche de son exposition au Stedelijk-Museum, Amsterdam, 1967

31 Niki de Saint Phalle, in Carla Schulz-Hoffmann (éd.), *Niki de Saint Phalle, Bilder – Figuren –Phantastische Gärten*, cat. d'expo. Kunsthalle der Hypo-Kulturstiftung, Munich, 1987, nouvelle édition Munich, 1997, avant-propos

32 *Ibidem*, p. 39

33 *Ibidem*, p. 20

34 Niki de Saint Phalle dans le film de Peter Schamoni (voir note 26), Munich, 1994

35 *Ibidem*

36 *Ibidem*

Niki & Jean

Joint Projects / Gemeinschaftsprojekte / Projets communs

hon

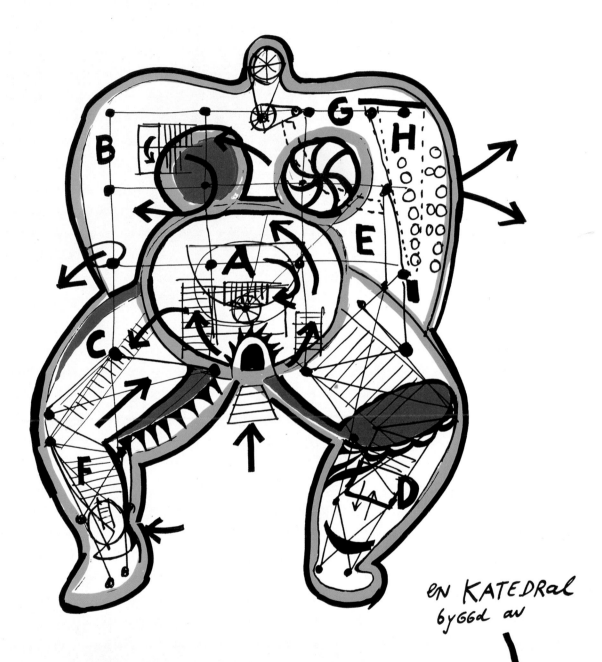

en KATEDRal byggd av

Moderna Museet

Alla dagar 12-17
Onsdagar 12-22
Efter 1/7 alla dagar 12-22

Niki de Saint Phalle
Jean Tinguely
Per Olof Ultvedt

1 hon – en Katedral byggd an Niki de Saint-Phalle,
Jean Tinguely, Per Olof Ultvedt, 1966 *cat. 1*

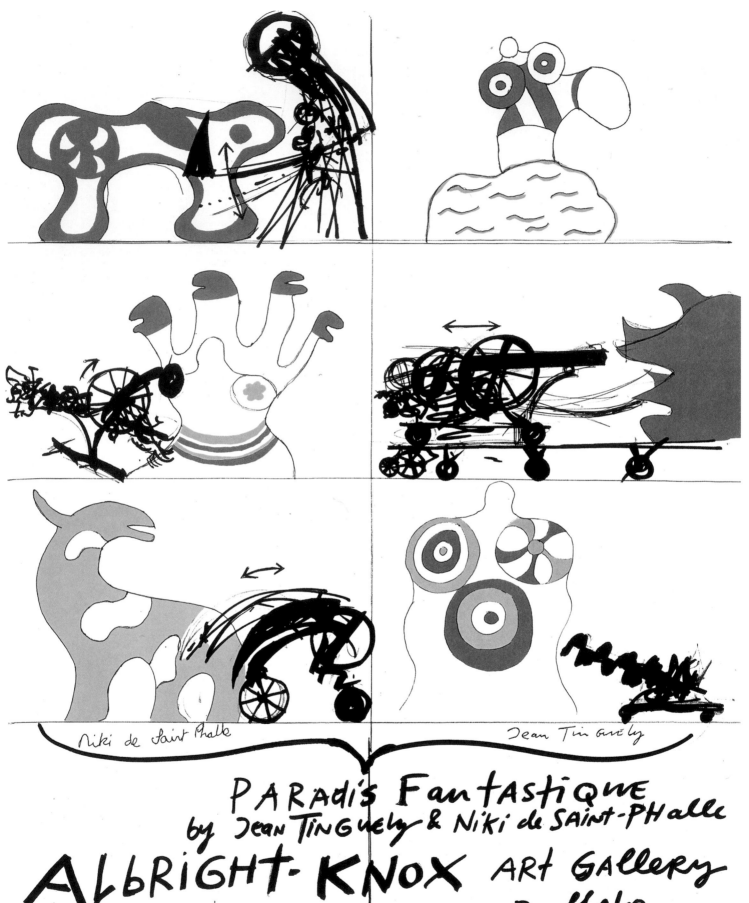

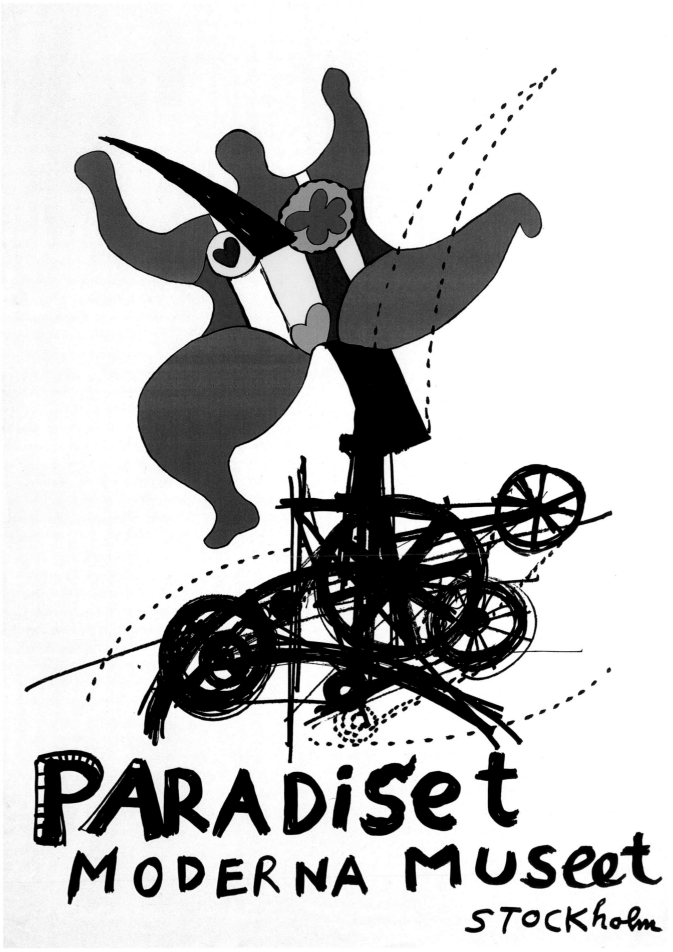

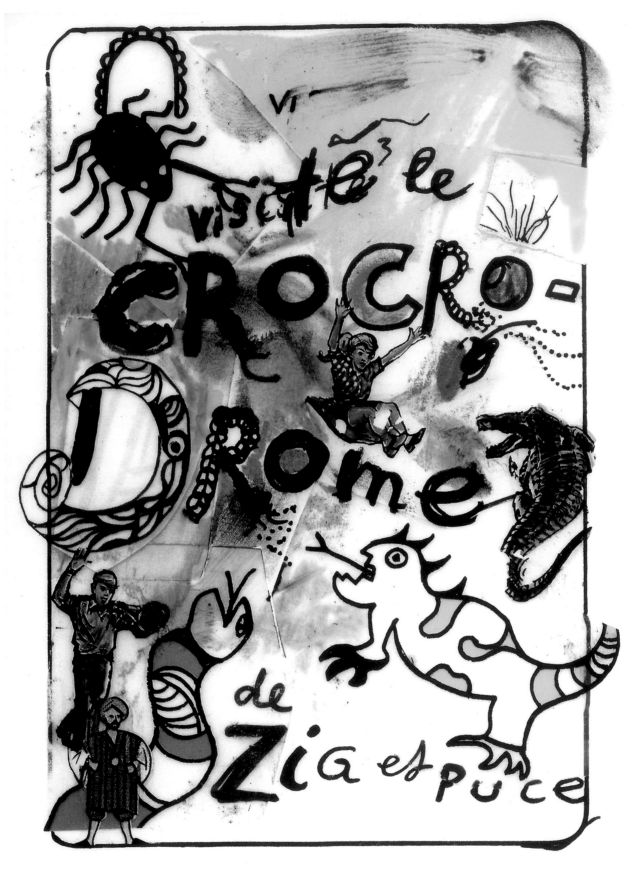

4 Visitéz le Crocrodrome de Zig et Puce, 1977 *cat. 5*

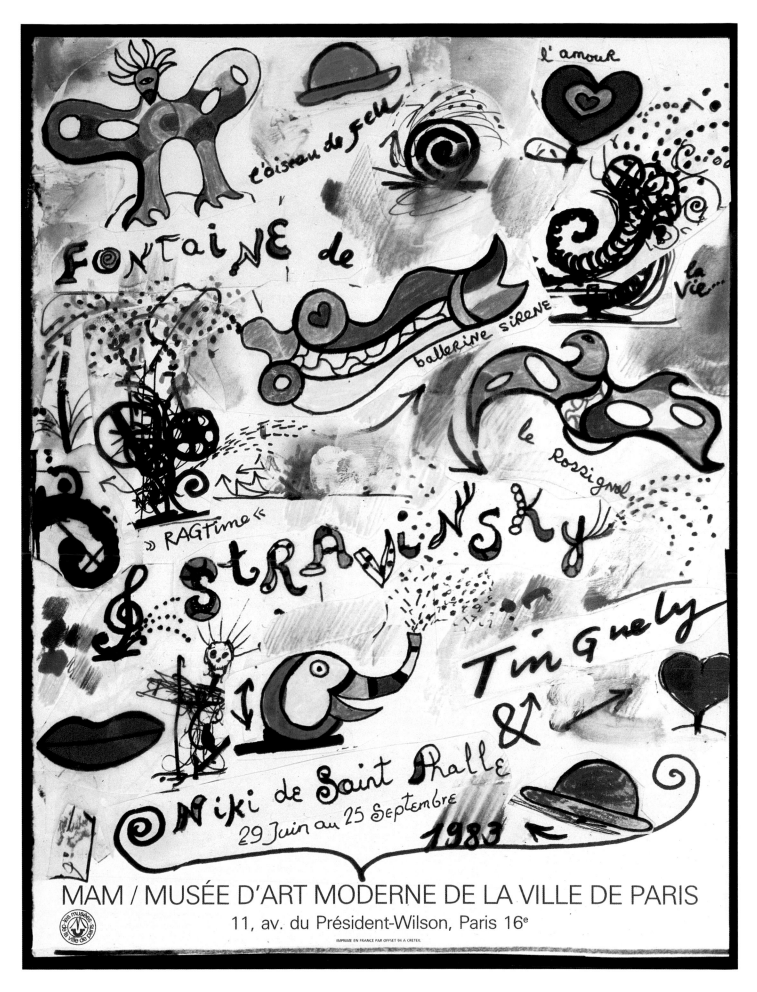

5 Fontaine de Stravinsky, 1983 *cat. 6*

Niki de Saint Phalle

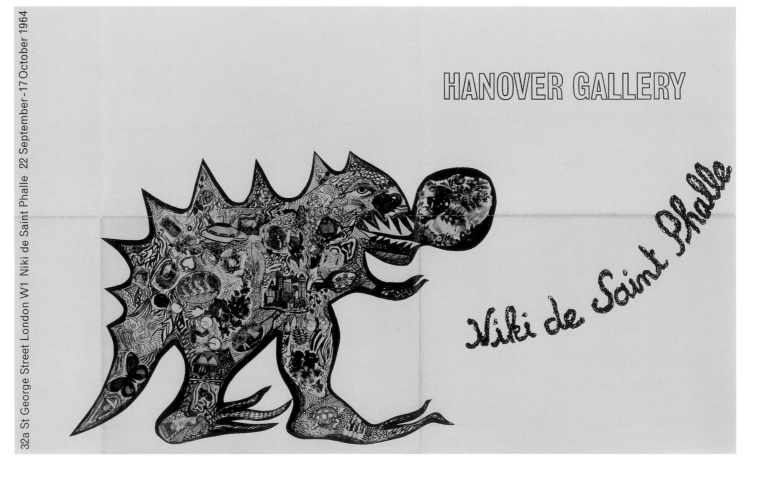

32a St George Street London W1 Niki de Saint Phalle 22 September–17 October 1964

HANOVER GALLERY

Niki de Saint Phalle

6 Niki de Saint Phalle, 1964 *cat. 9*

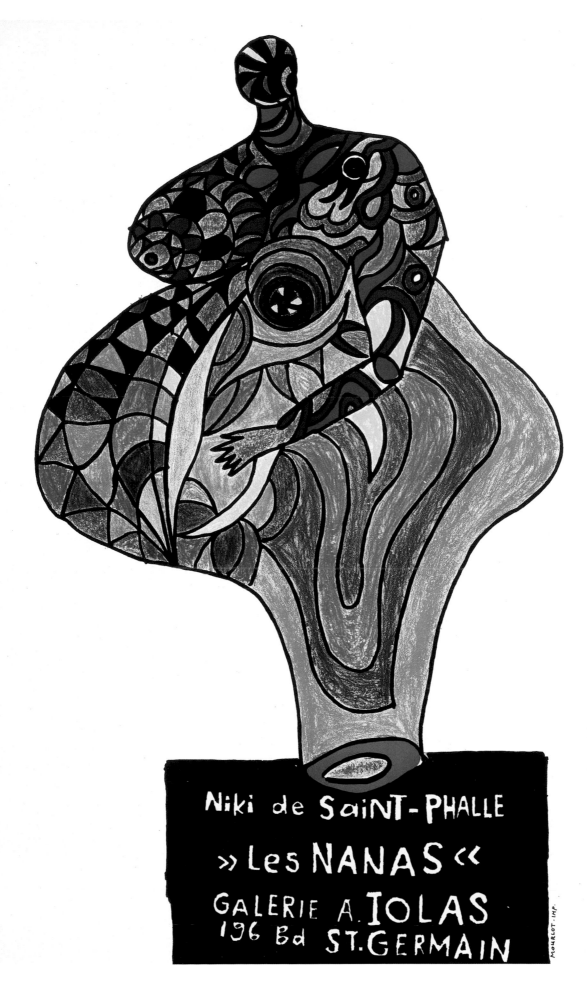

7 Les Nanas, 1965 *cat. 10*

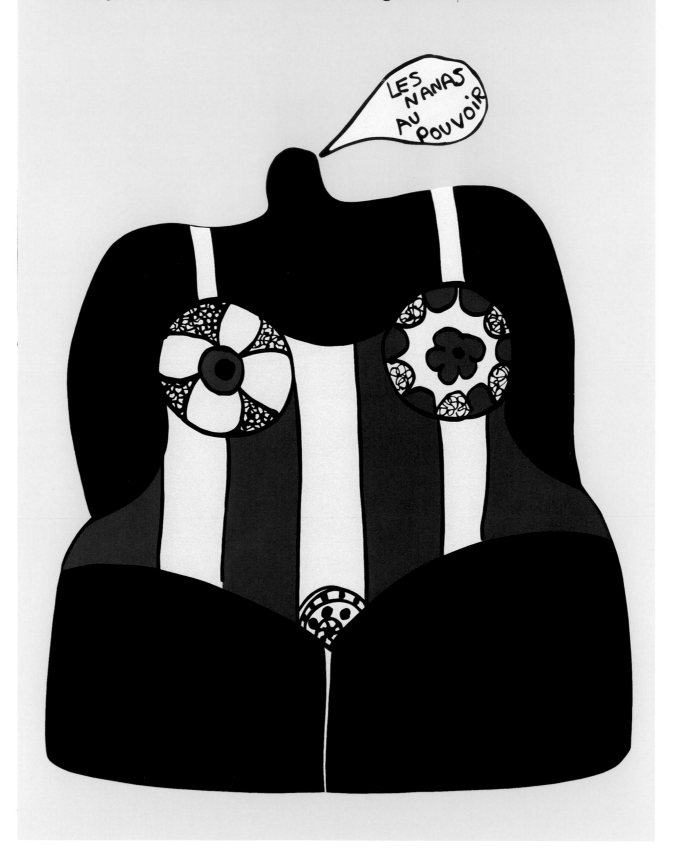

9 Je suis une sculpture de joie en polyester, 1968 *cat. 13*

10 Niki de Saint Phalle, Rainer von Diez, »ICH«, 1968 *cat. 14*

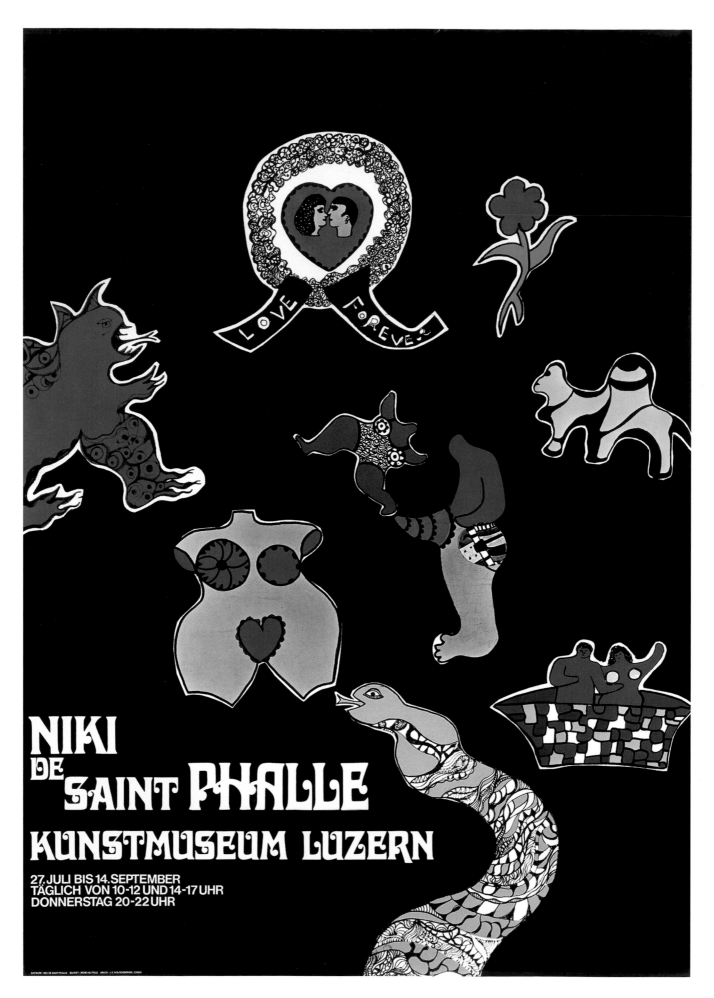

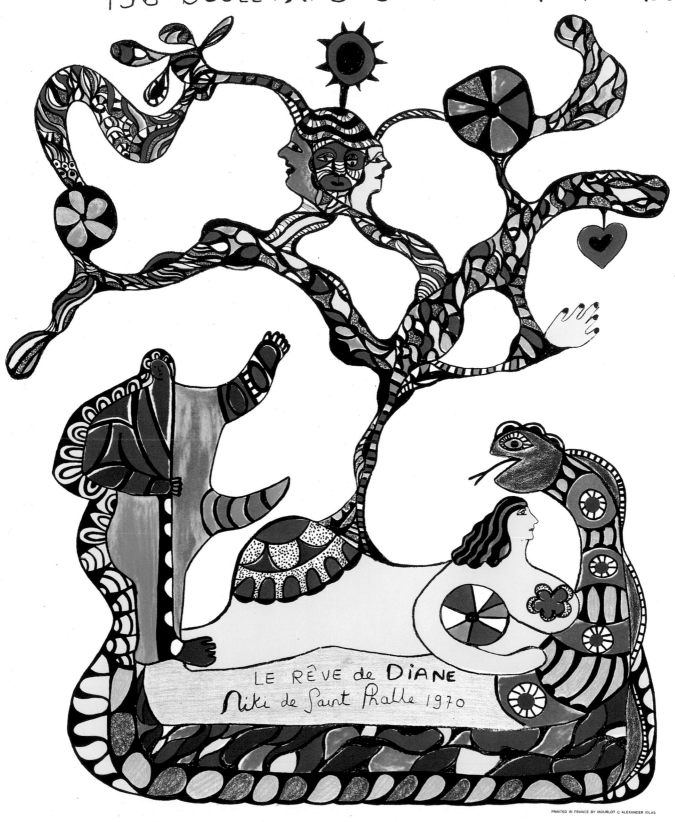

LE RÊVE de DIANE
Niki de Saint Phalle 1970

13 Le Rêve de Diane, 1970 *cat. 19*

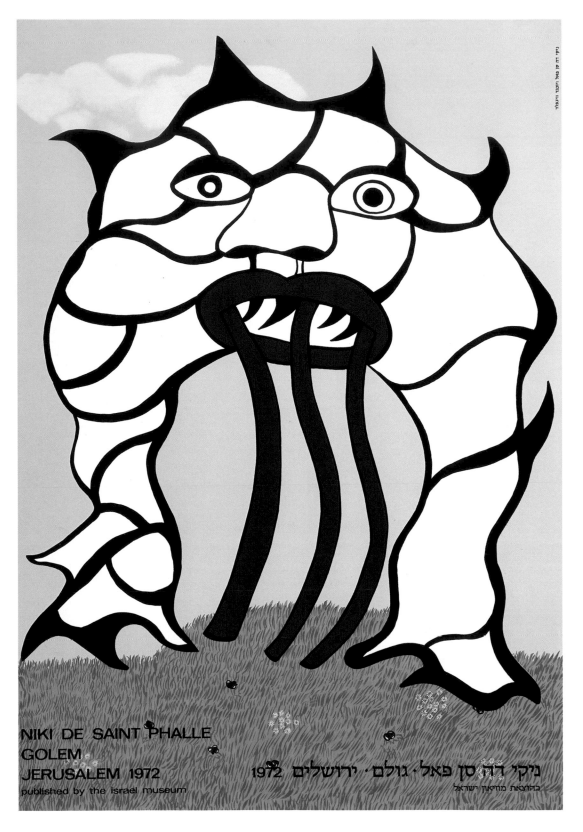

14 Golem, 1972 *cat. 23*

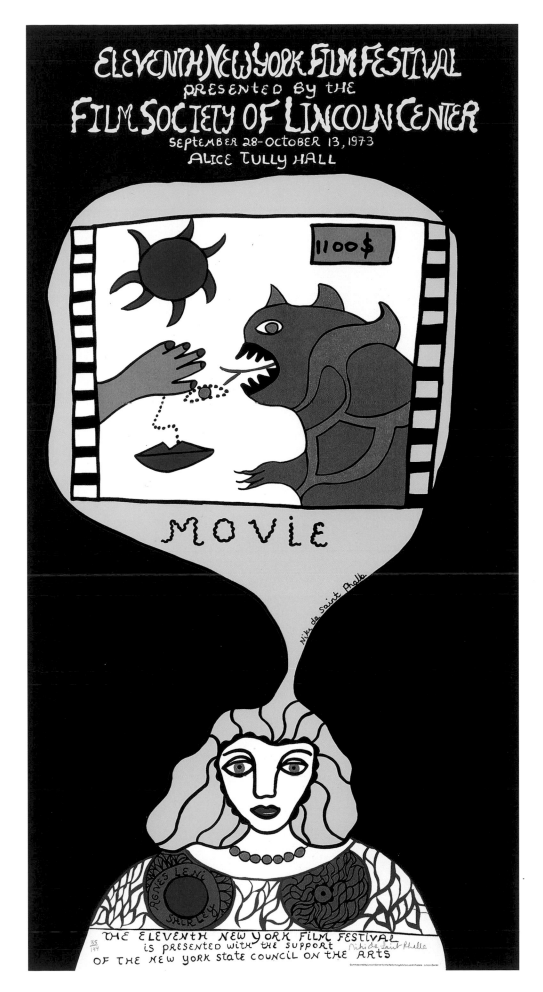

15 Eleventh New York Film Festival, 1973 *cat. 25*

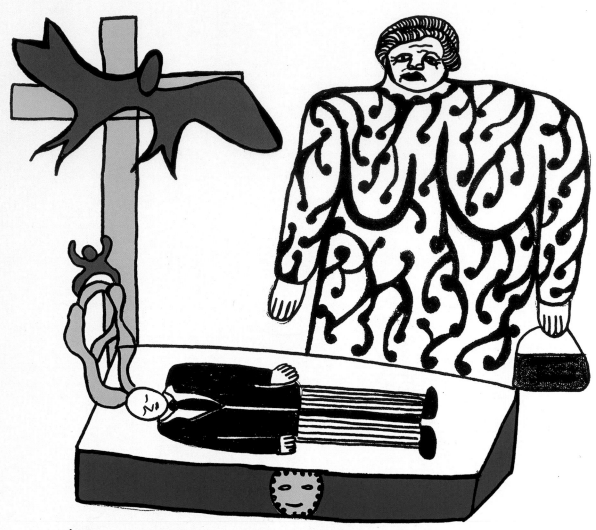

les funerailles de PAPA
Niki de Saint PHALLE
GALERIE IOLAS 1972
PARis MiLAN New YORK etc.

16 Les funerailles de Papa, 1972 *cat. 24*

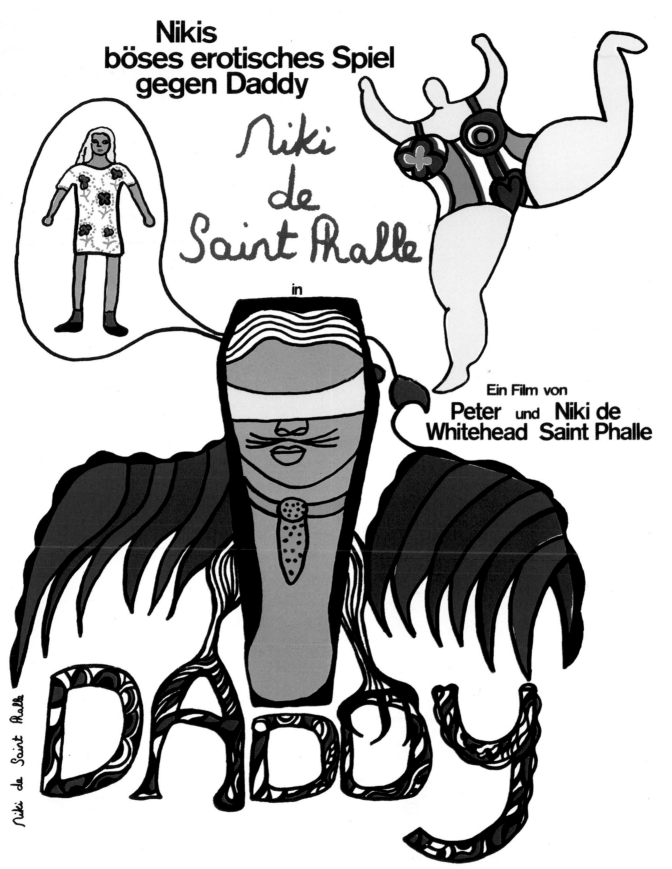

17 DADDY, Nikis böses erotisches Spiel gegen Daddy, 1973 *cat. 26*

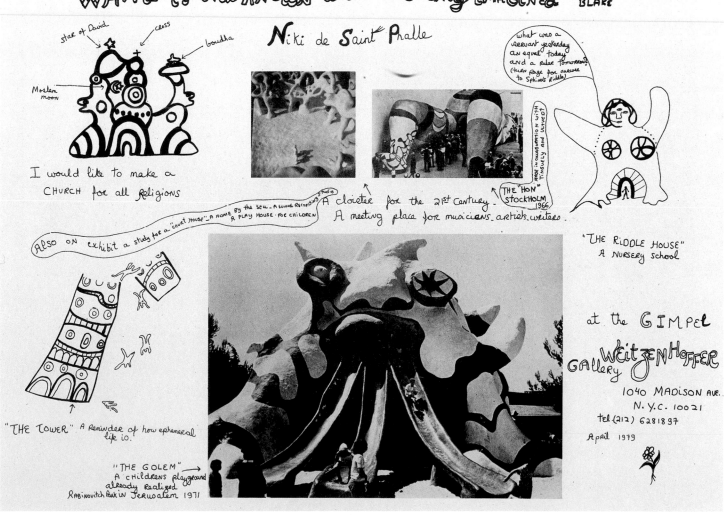

"WHAT is NOW KNOWN was ONCE ONLY IMAGINED" BLAKE

Niki de Saint Phalle

star of David
cross
boudha
Moslem moon

what was a relevant yesterday an equal today and a ruler tomorrow (turn page for answer to Sphinx riddle)

MADE IN COLLABORATION WITH TINGUELY AND ULTVEDT

I would like to make a CHURCH for all Religions

THE "HON" STOCKHOLM 1966

A cloister for the 21st Century. A meeting place for musicians, artists, writers.

ALSO ON exhibit a study for a "court house" A home by the sea. A sound recording Studio A PLAY HOUSE · FOR CHILDREN

"THE RIDDLE HOUSE" A NURSERY school

at the GIMPel WEITZENHOFFER GALLERY
1040 MADISON AVE.
N.Y.C. 10021
tel.(212) 6281897
April 1979

"THE TOWER" A Reminder of how ephemeral life is.

"THE GOLEM" → A children's playground already realized RABINOVITCH Park in Jerusalem 1971

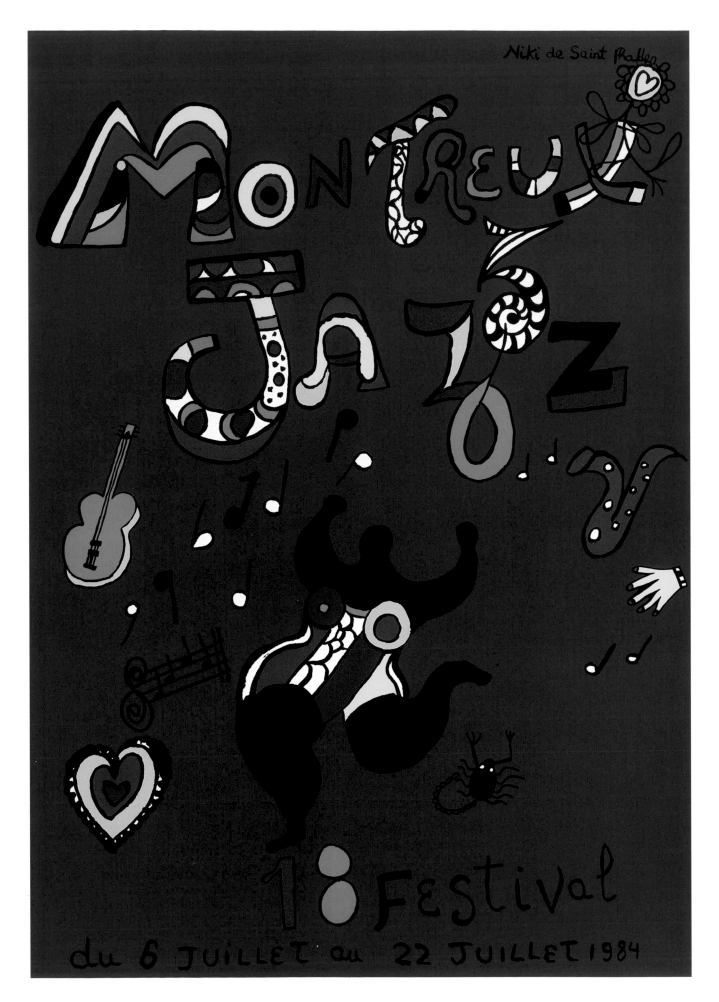

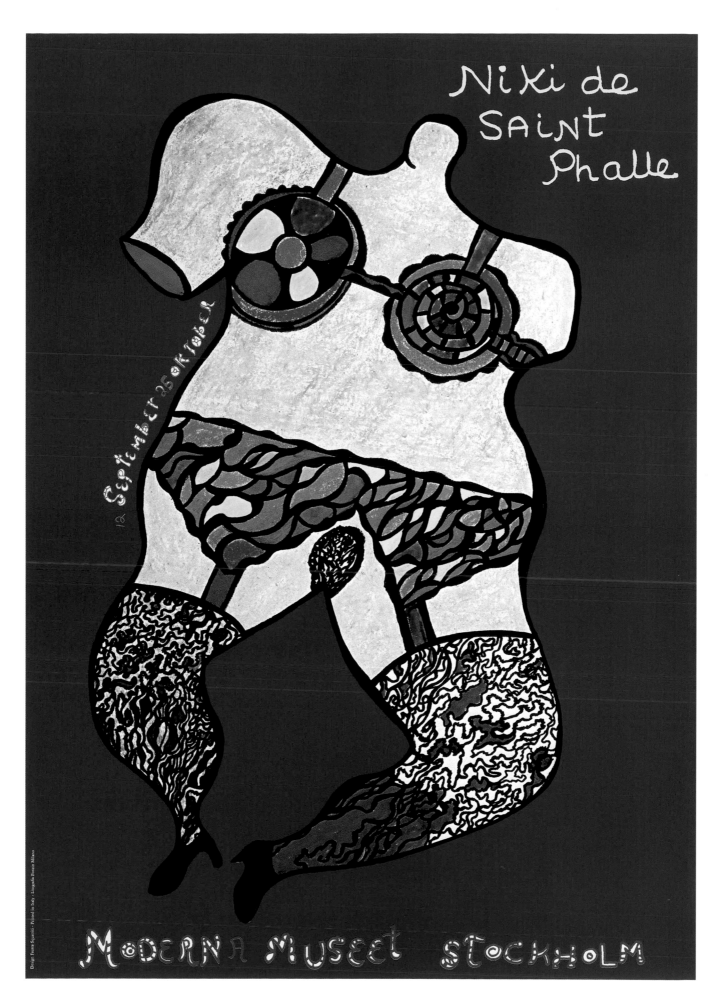

Niki de
Saint
Phalle

1a September as oktober

Moderna Museet Stockholm

21 Niki de Saint Phalle, 1981 *cat. 33*

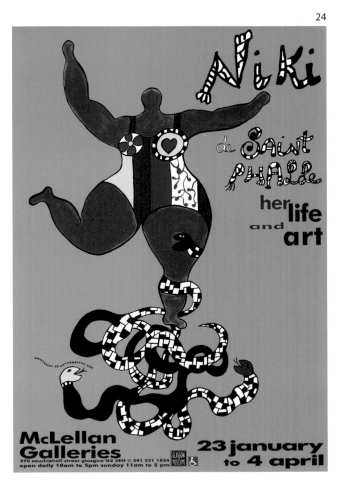

22 Niki de Saint Phalle, Parfum Art, 1991 *cat. 39*
24 Niki de Saint Phalle, Her Life and Art, 1993 *cat. 41*

23 Niki de Saint Phalle, l'inivitation au musée, 1993 *cat. 40*
25 Cirque Knie, 1994 *cat. 45*

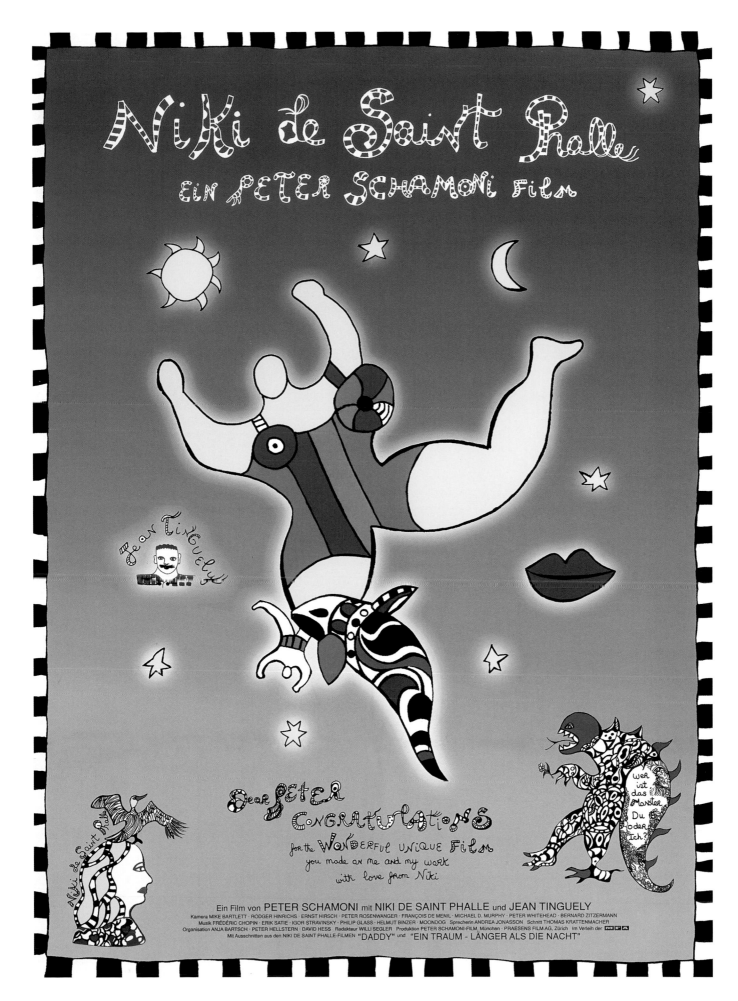

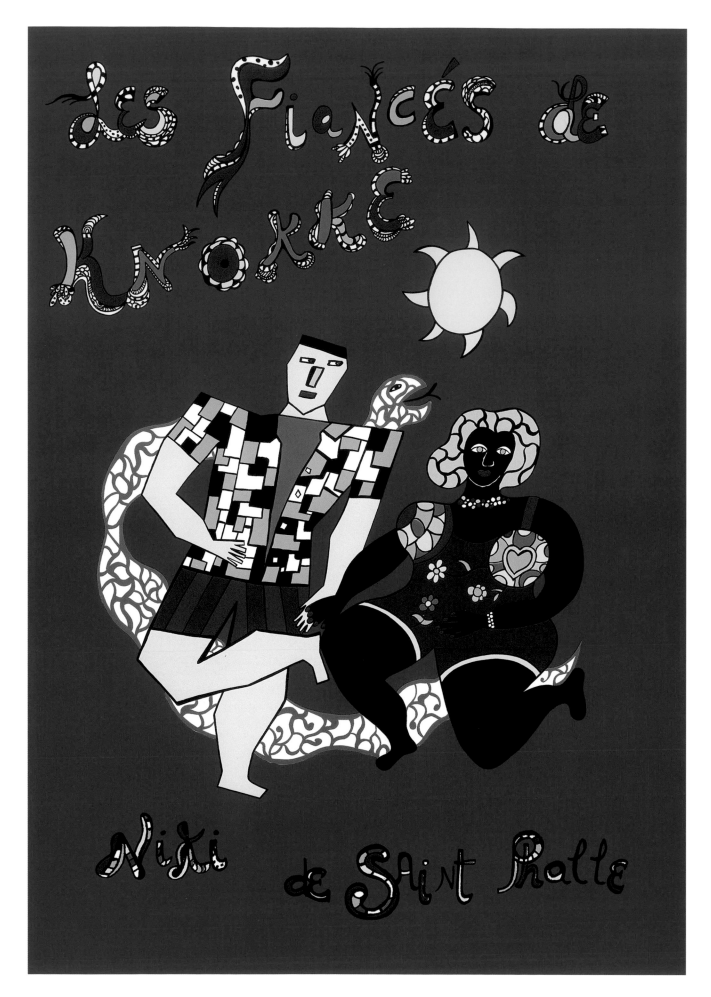

27 Niki de Saint Phalle, Les Fiancés de Knokke, 1993 *cat. 43*

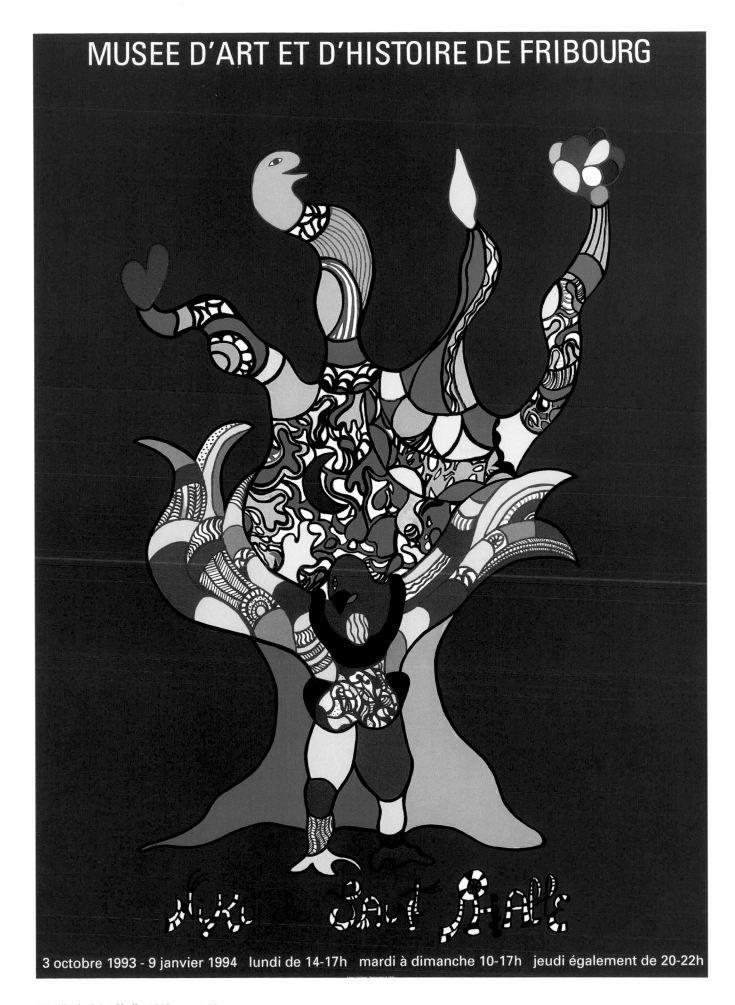

MUSEE D'ART ET D'HISTOIRE DE FRIBOURG

3 octobre 1993 - 9 janvier 1994 lundi de 14-17h mardi à dimanche 10-17h jeudi également de 20-22h

Jean Tinguely

31 Tinguely at the Dwan Gallery, 1963 *cat. 51*

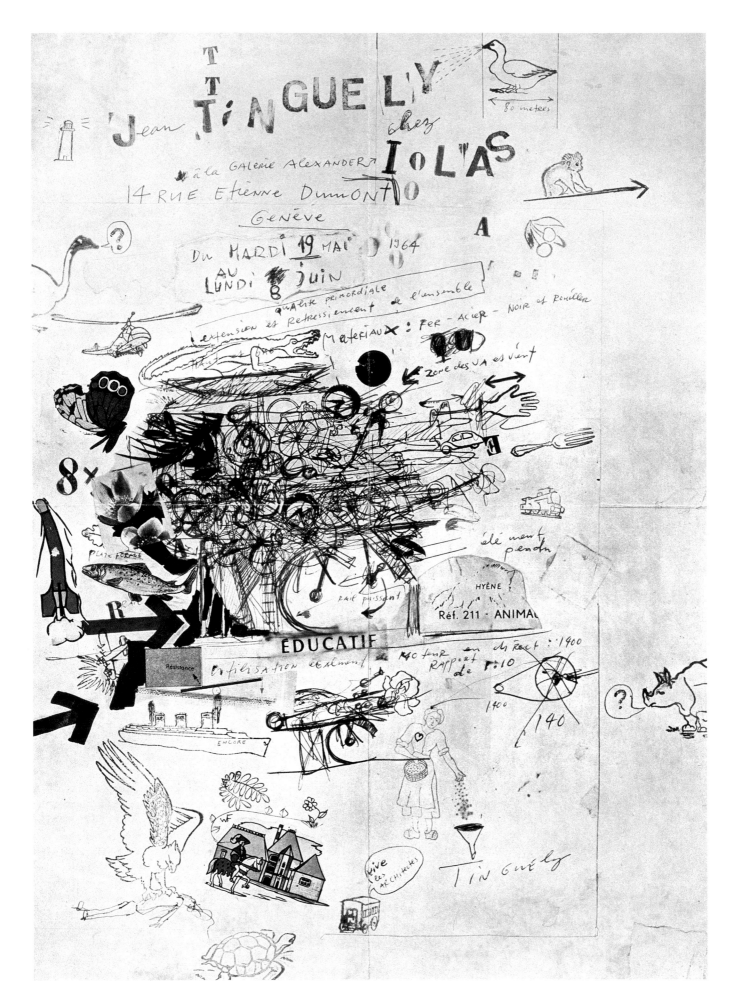

32 Jean Tinguely chez Galerie Alexander Iolas, 1964 *cat. 52*

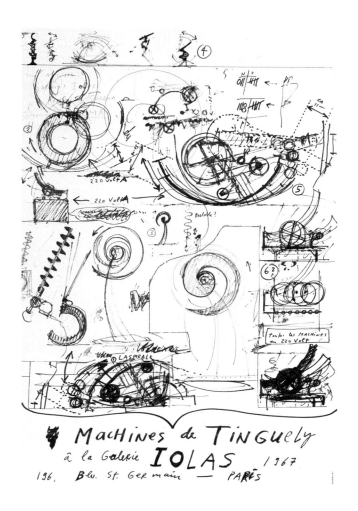

33 Machines de Tinguely à la Galerie Iolas, 1967 *cat. 54*

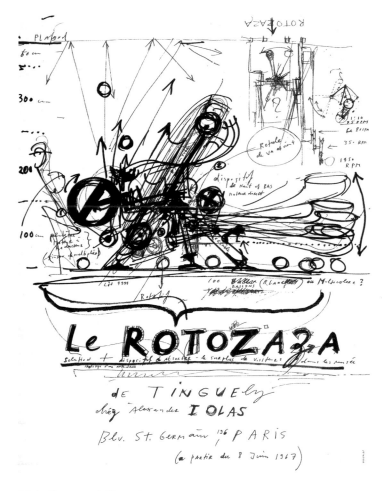

34 Le Rotozaza de Tinguely
chez Galerie Alexander Iolas, 1967 *cat. 56*

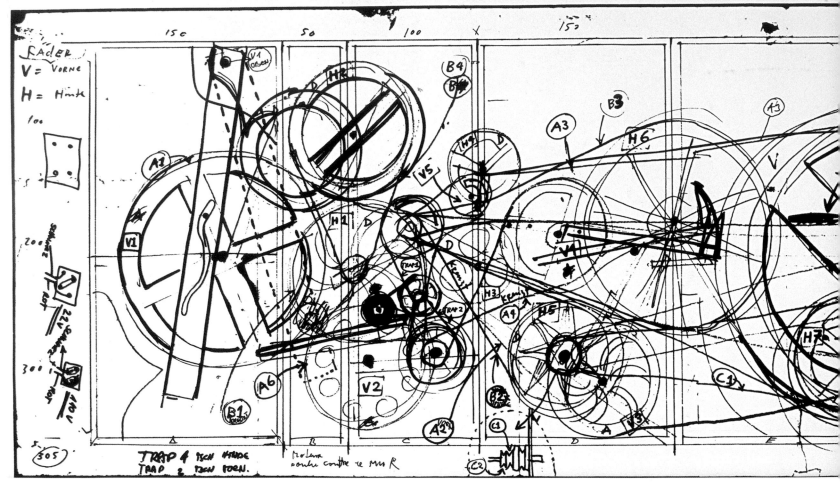

35 Requiem Pour Une Feuille Morte, 1966 *cat. 57*

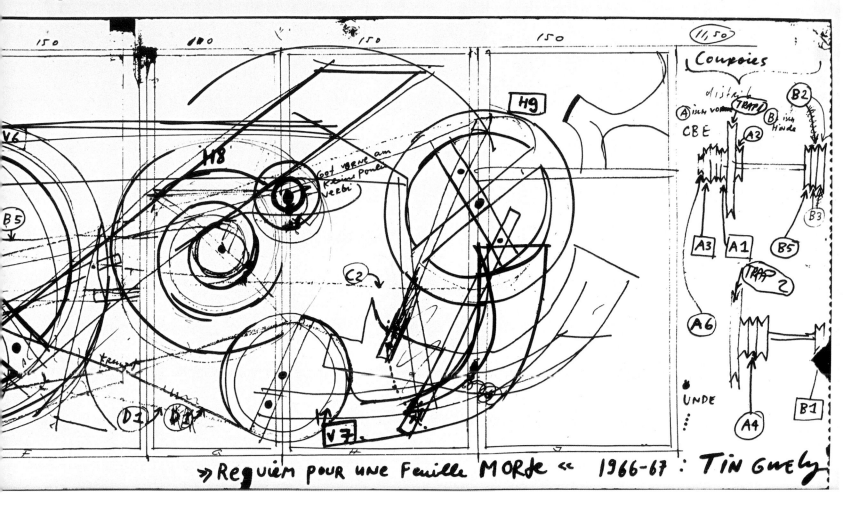

»Requiem pour une Feuille MORte« 1966-67 : TiN Guely

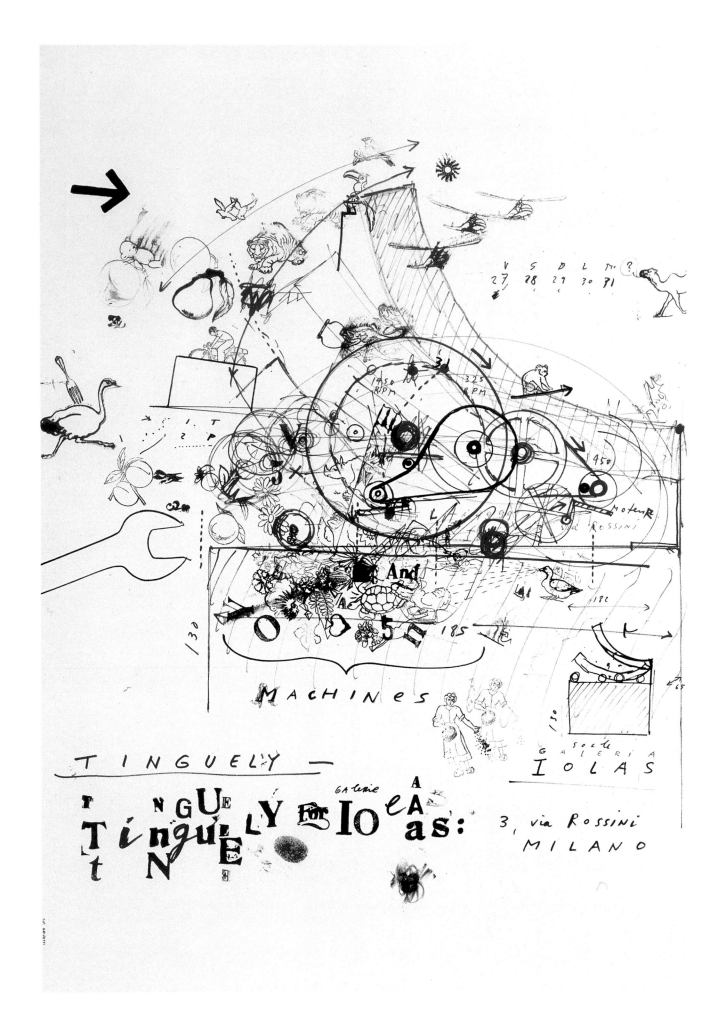

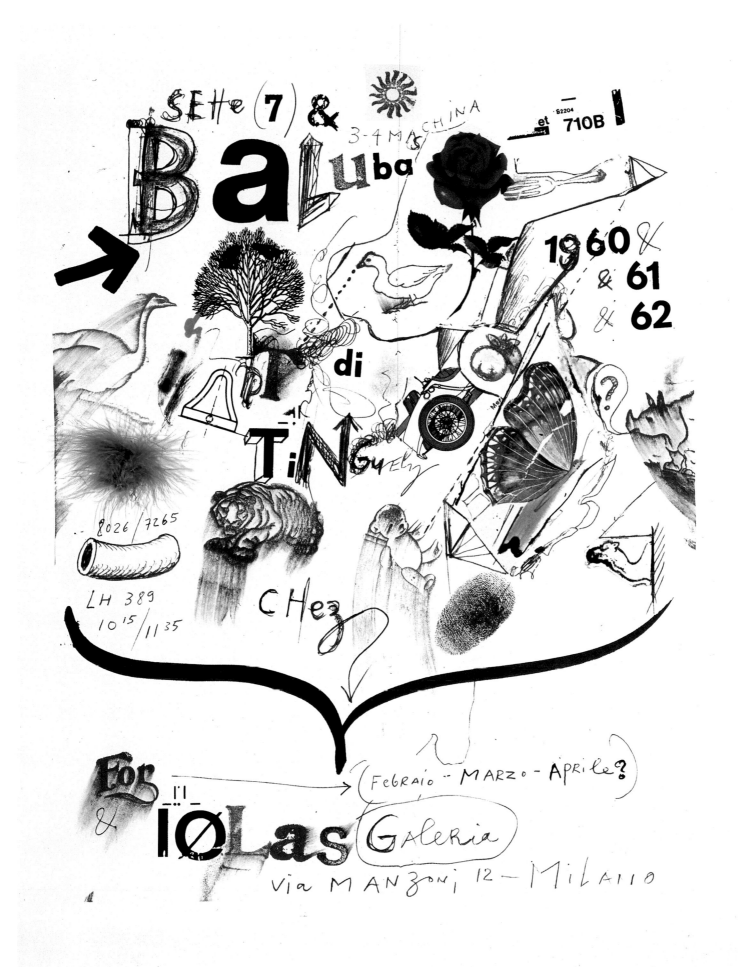

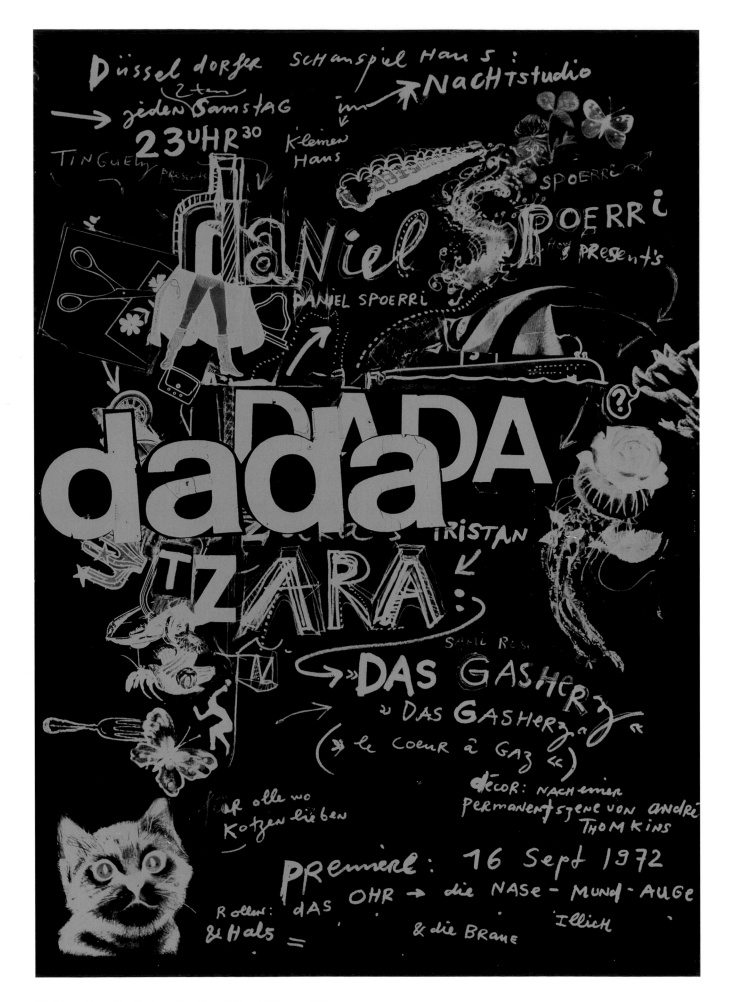

38 Tristan Tzara: Das Gasherz, Première: 16 Sept 1972 *cat. 68*

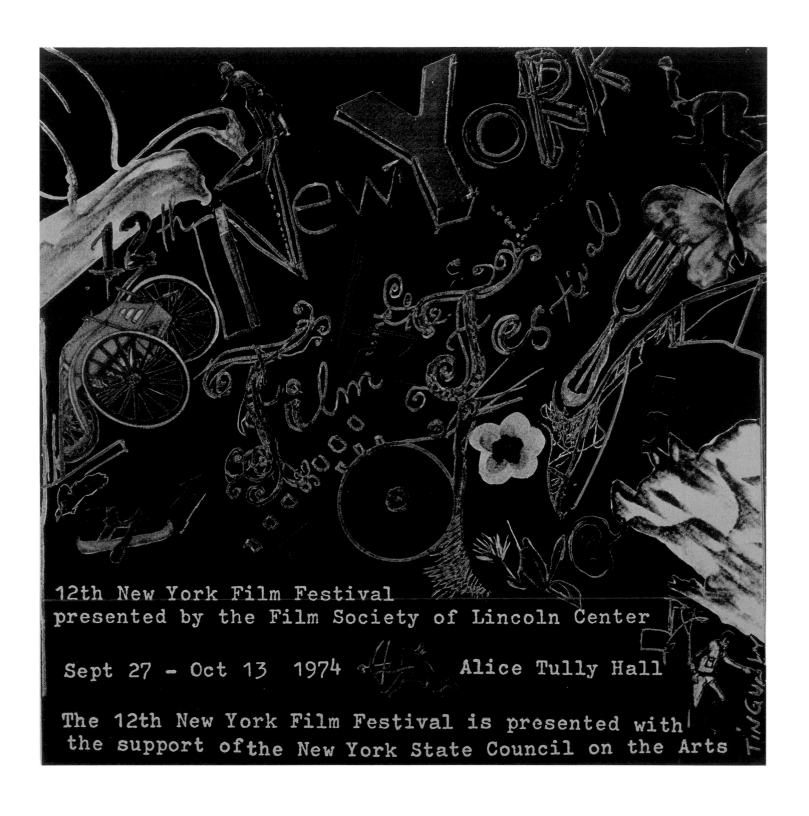

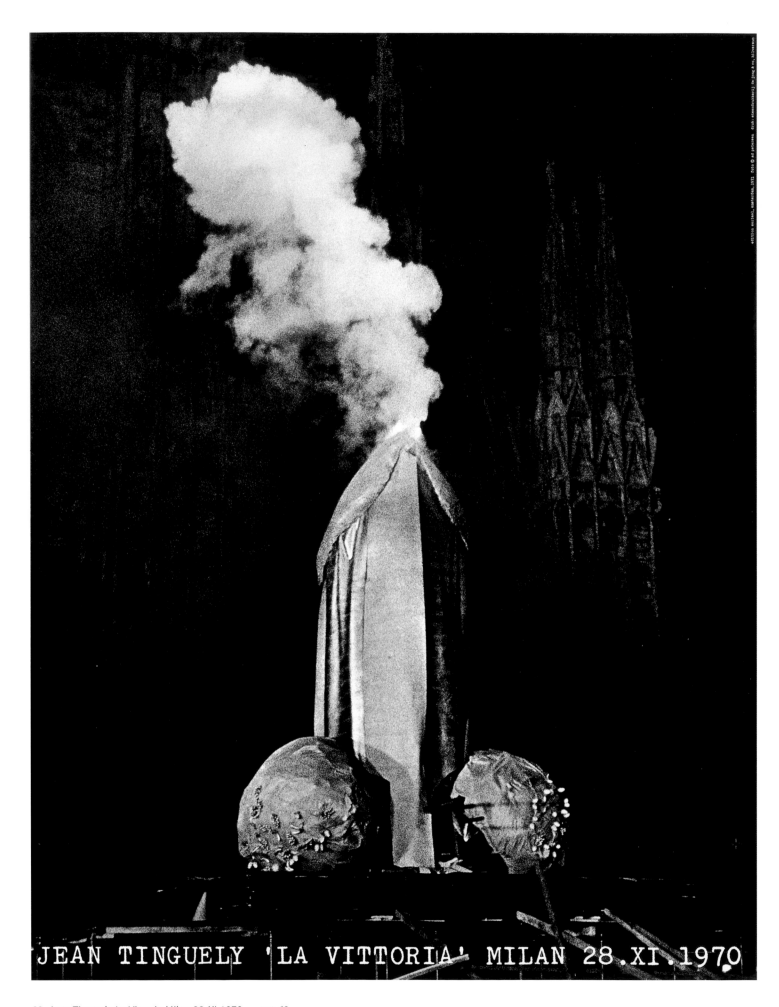

JEAN TINGUELY 'LA VITTORIA' MILAN 28.XI.1970

40 Jean Tinguely La Vittoria Milan 28.XI.1970 *cat. 63*

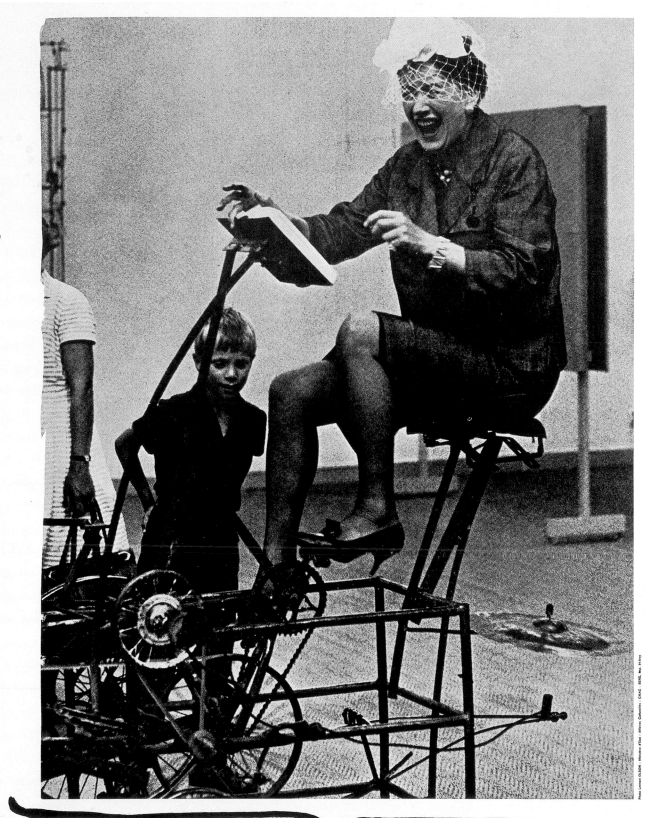

Tinguely

CENTRE NATIONAL »d'Art« contemporain, 11 rue Berryer
tous les jours, sauf le MARDi, de 12 HR à 19 HR PARIS 8

A PARTIR du
12 Mai
Jusqu'au 5 Juillet

41 Tinguely, 1971 *cat. 64*

42 Maschinen Plastiken von Jean Tinguely, 1972 *cat. 65*

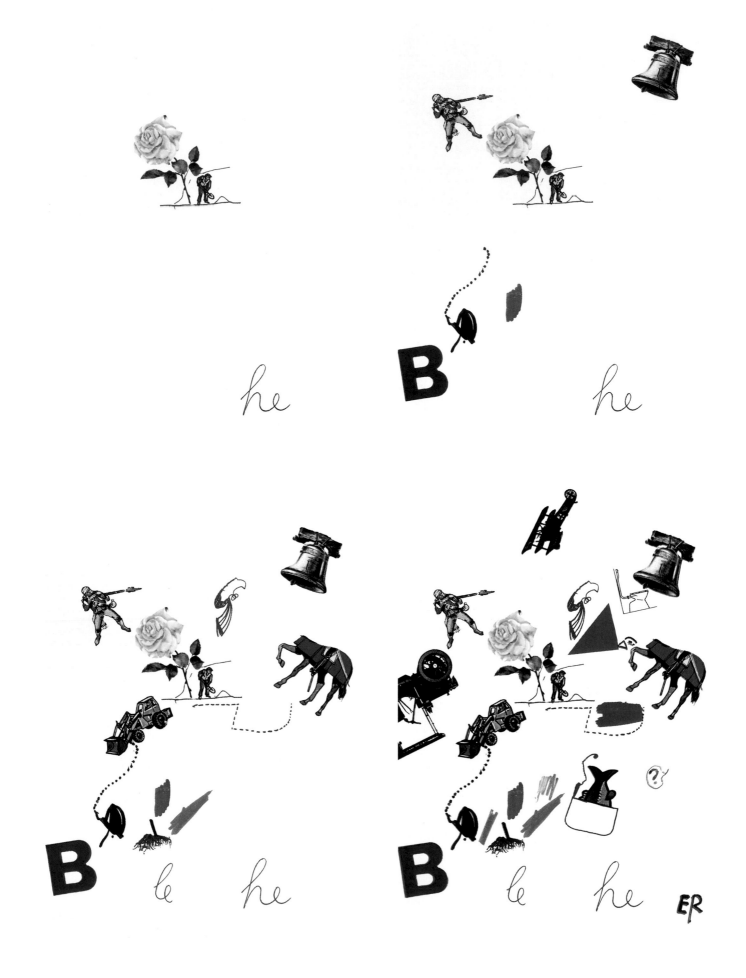

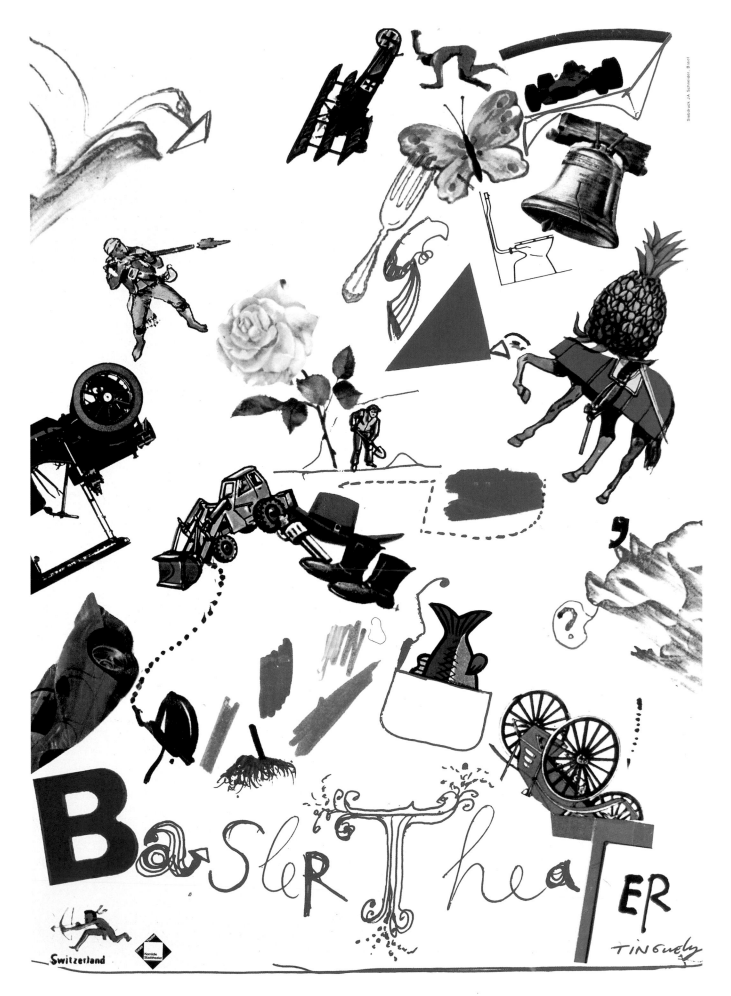

44 a–e Basler Theater, 1974 *cat. 72*

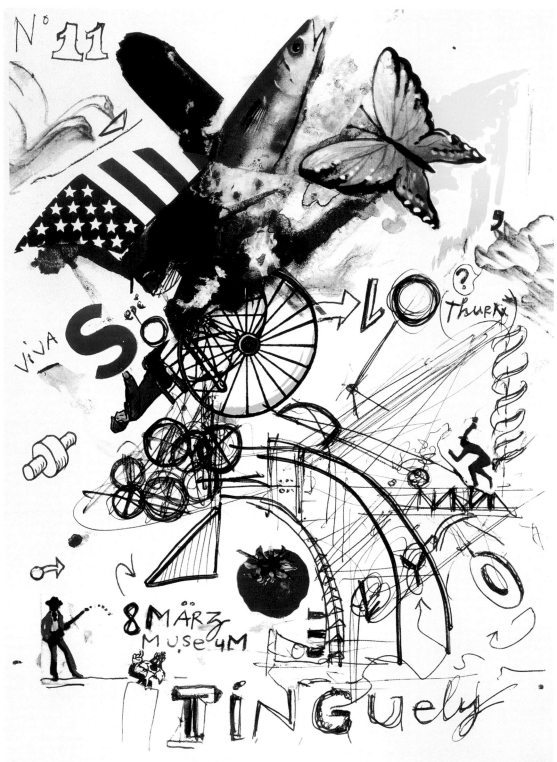

Museumsfoyer Solothurn 8. März bis 7. April 1974

Jean Tinguely – Maschinen, Zeichnungen, Dokumente,
Fotos und Fotobuch von Leonardo Bezzola

45 Jean Tinguely – Maschinen, Zeichnungen, Dokumente …, 1974 *cat. 73*

Eröffnet 1980
Dienstag bis Samstag
10–12 und 14–17 Uhr

Hommage à Paul Kle

Jean Tinguely

46 Museum für Gegenwartskunst, Basel, 1980 *cat. 83*

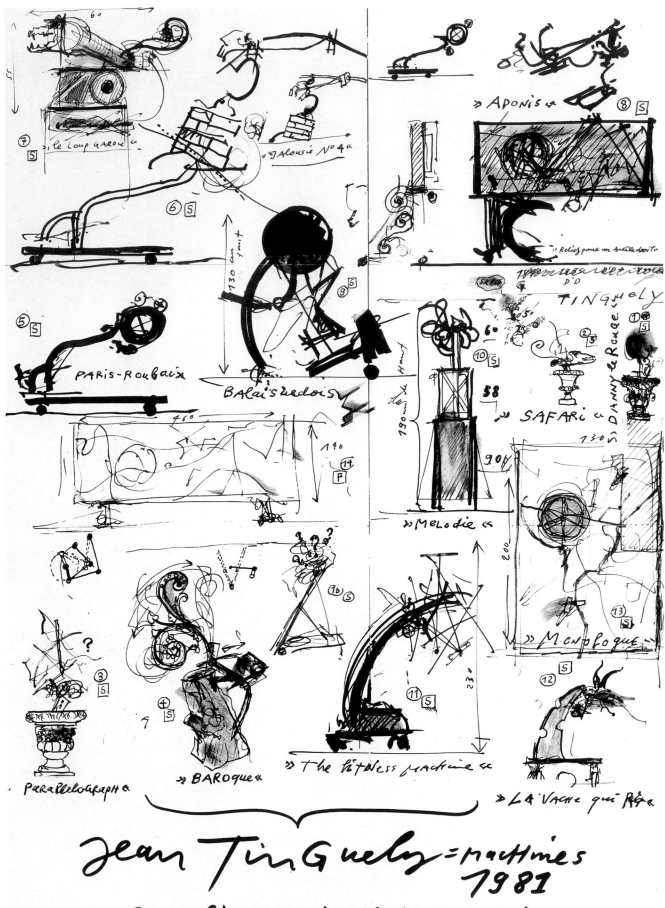

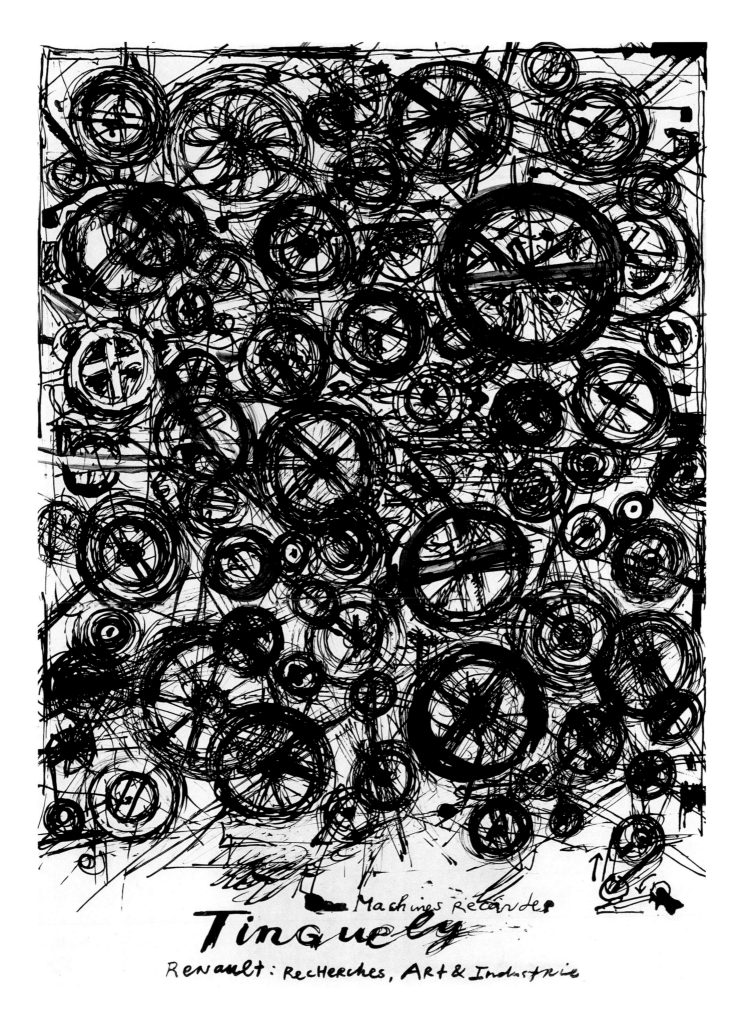

48 Tinguely, Machines Recentes, 1981 *cat. 85*

Mémorial Jo Siffert

Course de côte St-Ursanne - Les Rangiers
22-23 août 1981

50 le 4 ième Grand Prix à Gollion, 1990 *cat. 125*

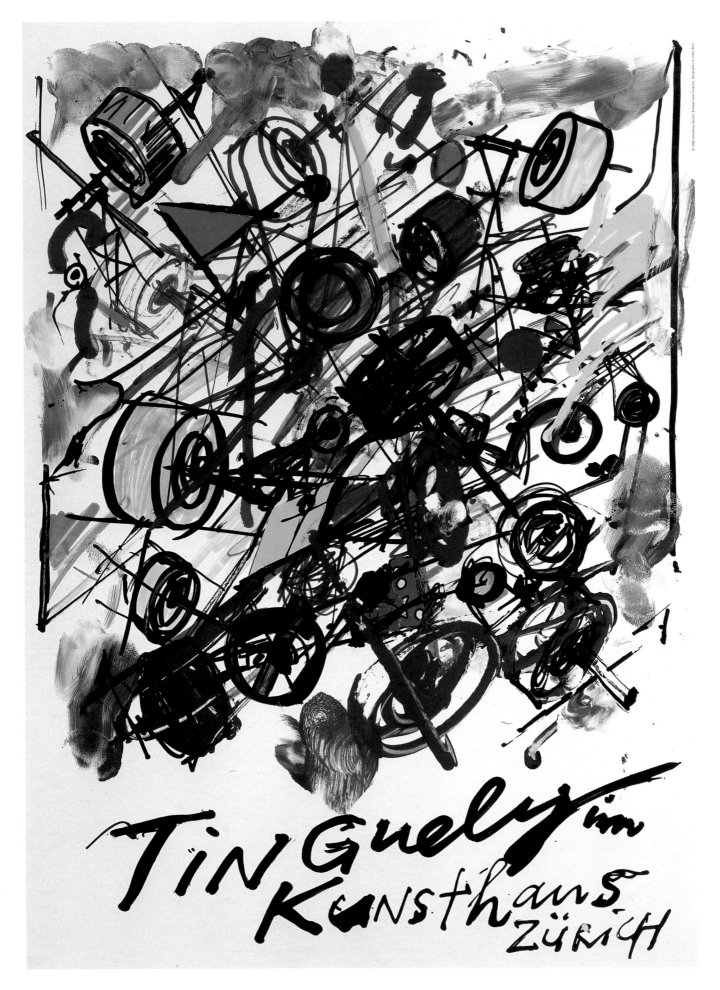

51 Tinguely im Kunsthaus Zürich, 1982 *cat. 88*

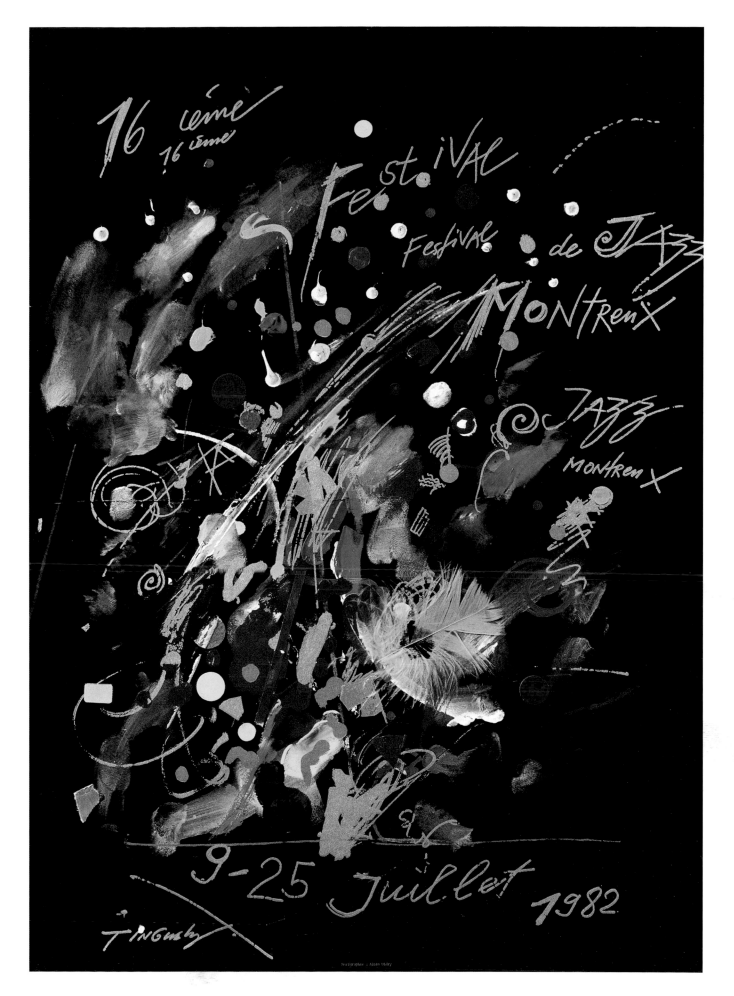

53 25-ième Rose d'or Montreux 85, 1985 *cat. 96*

54 Tinguely på Louisiana, 1986 *cat. 103*

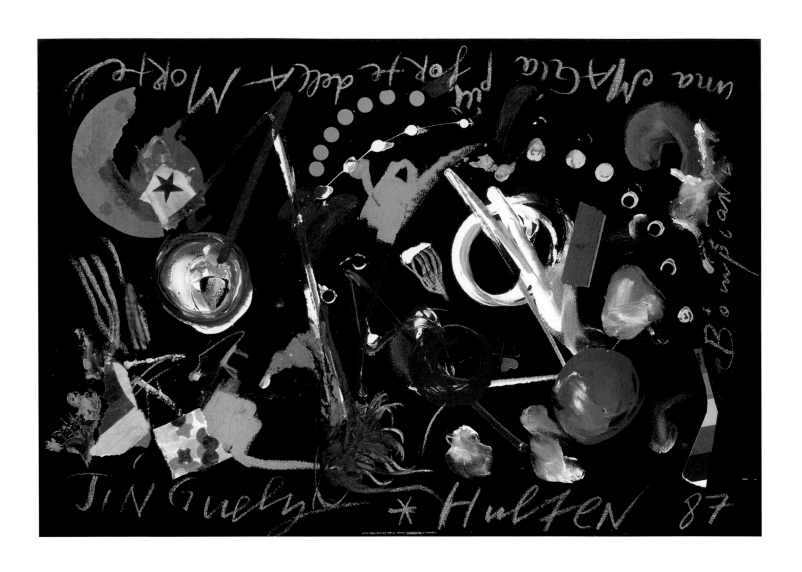

55 Tinguely * Hulten 87, una magia piu forte della Morte, 1987 *cat. 106*

Musée
national d'art moderne

Centre Georges Pompidou

8 décembre 1988 - 27 mars 1989
L'exposition a bénéficié du soutien de Pro Helvetia, Fondation suisse pour la culture.

57 Tinguely, Moscou, 1990 *cat. 118 b*

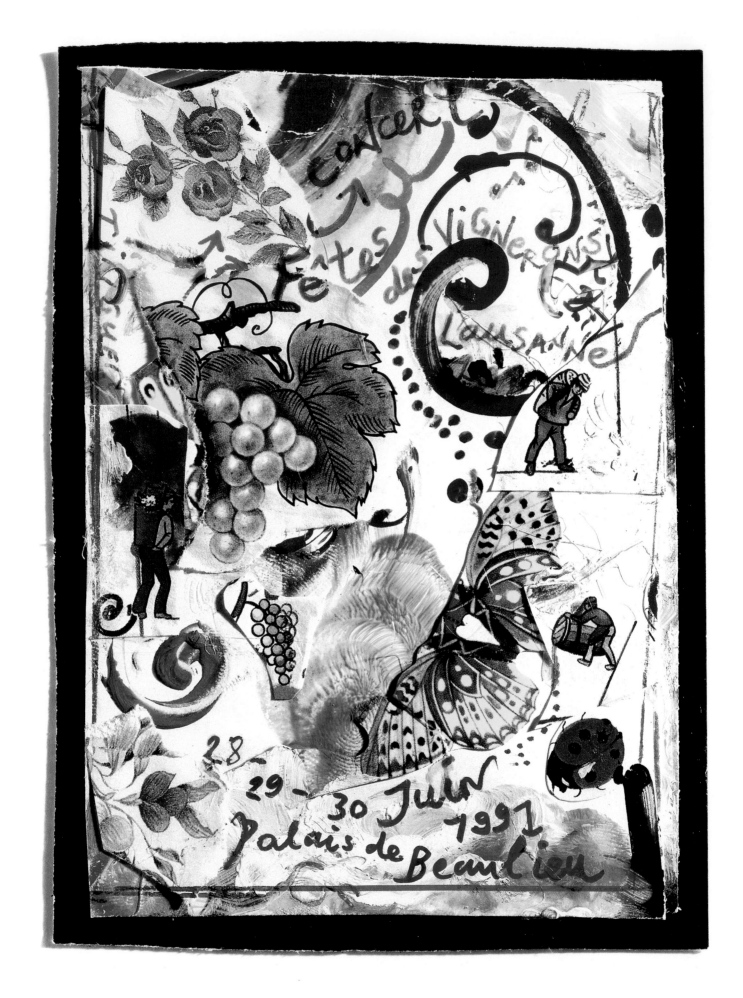

59 Fêtes des Vignerons, 1991 *cat. 131*

Ein poetisches Varieté von

ANDRé

TIN GUELY

HELLER Heller Heller

Heller

H.

Ermöglicht mit Hilfe der österreichischen Spielbanken AG.

FLIC FLAC

Täglich um 20.30 Uhr, Samstag und Sonntag auch um 17 Uhr.

Kartenvorverkauf im Theater an der Wien.

Achtung! Unwiderruflich letzte Aufführung in Wien.

Zweite veränderte Fassung. Als Produktion der Wiener Festwochen 1982 vom 2. bis 20. Juni. Im Großen Saal des Wiener Konzerthauses.

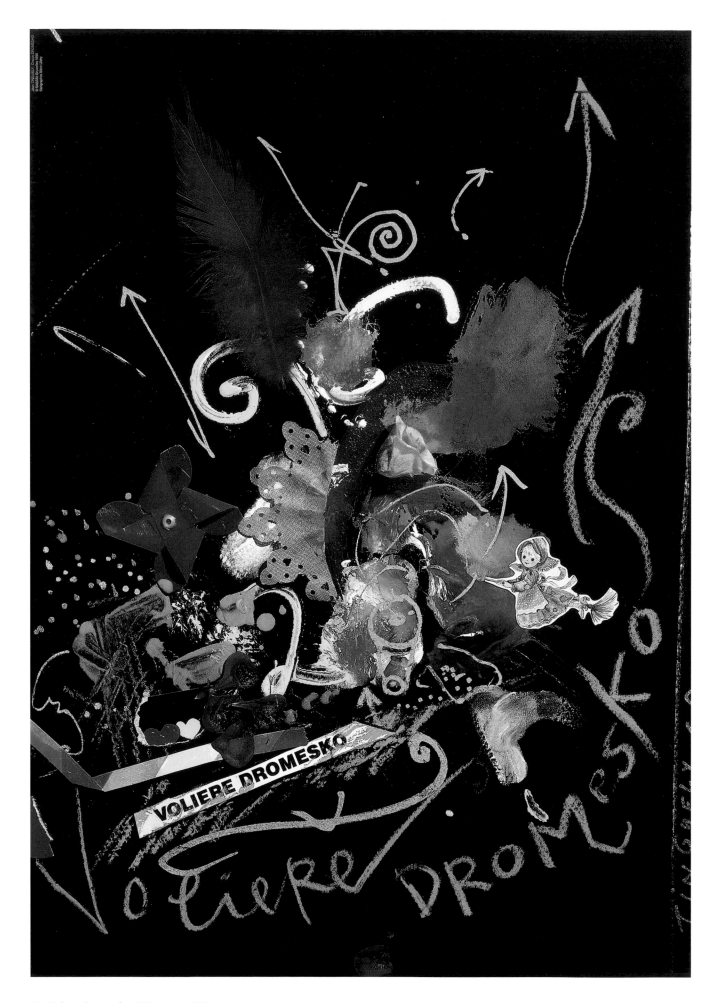

61 Voliere Dromesko, 1991 *cat. 133*

Catalogue Raisonné of Posters
Claus von der Osten

Catalogues and other publications quoted in abbreviated form in the catalogue raisonné refer to the following works:

Künstlerplakate Döring, Jürgen, *Künstlerplakate Picasso–Warhol–Beuys*, Museum für Kunst und Gewerbe, Hamburg, Heidelberg 1998

Kunstmuseum Wolfsburg *L'Esprit de Tinguely*, exhib. cat., Kunstmuseum Wolfsburg, and Museum Jean Tinguely, Basle, Ostfildern/Ruit 2000/01

Museum Tinguely Krempel, Ulrich, *Niki de Saint Phalle* (works from 1952–2001 from Niki de Saint Phalle's donation to the Sprengel Museum),

Museum Jean Tinguely, Basle, Ostfildern/Ruit 2000/01

Wichmann/Hufnagel Wichmann, Hans and Florian Hufnagel (eds.), *Künstlerplakate* (France/USA, 1950–2000), Die Neue Sammlung, Munich, Basle/Boston/Berlin 1991

Niki & Jean
Joint projects

1 hon – en Katedral byggd an Niki de Saint-Phalle, Jean Tinguely, Per Olof Ultvedt *plate 1*
Moderna Museet, Stockholm 1966
Color silkscreen, 100 x 70 cm

2 Paradis Fantastique *plate 2*
Albright-Knox Art Gallery, Buffalo 1967/68
Silkscreen, 56 x 43 cm

3 PARADISET *plate 3*
Moderna Museet, Stockholm 1972
Color offset, 100 x 70 cm
The sculptures were presented to the Moderna Museet, Stockholm by the artists and placed in the museum's gardens in 1971
Lit.: Künstlerplakate, p. 135

5 Visitéz le Crocrodrome de Zig et Puce *plate 4*
Centre Georges Pompidou, Paris 1977
Color offset, 67 x 45 cm
The large, accessible sculpture with 'ghost train' and museum by Daniel Spoerri were created in the entrance area for the opening of the Centre Georges Pompidou.
Lit.: Kunstmuseum Wolfsburg, p. 387

6 Fontaine de Stravinsky *plate 5*
MAM / Musée d'Art Moderne de la Ville de Paris, 1983
Color offset, 53 x 40 cm
The color drawing was published in 1991 by Nouvelles Images S.A. Editeurs, Lombreuil, in a slightly enlarged format (80 x 60 cm).
The brightly colored elements that make up the fountain, completed in 1983, have been a popular attraction on the square outside the Centre Georges Pompidou ever since.

8 Niki de Saint Phalle, Sculptures de Niki stabilisée par Jean Tinguely
Galerie de France and JGM Galerie, Paris 1989
Color offset, 63 x 43 cm
Lit.: Museum Tinguely, p. 286

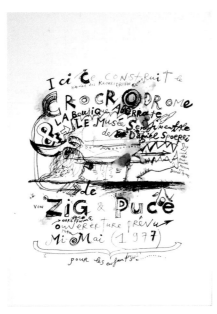

4 Ici ce construit le Crocrodrome & le musée sentimentale de Daniel Spoerri
Centre Georges Pompidou, Paris 1977
Offset print on light paper, 70 x 49 cm

7 Avignon, France Culture 88
Avignon 1988
Color offset on Arches paper, 71 x 49.5 cm
Edition of 150

Niki de Saint Phalle

9 Niki de Saint Phalle *plate 6*
Hanover Gallery, London 1964
Offset on yellow paper, 35.7 x 57.2 cm

10 Les Nanas *plate 7*
Galerie A. Iolas, Paris 1965
Color lithograph, 76.5 x 51.8 cm
Printing: Mourlot, Paris
First 'Nana' exhibition
Lit.: Künstlerplakate, p. 130

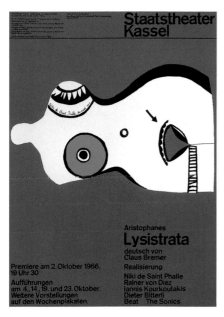

11 Aristophanes: Lysistrata
Staatstheater Kassel, Premiere on 2 October 1966
Color silkscreen, 84.5 x 59.7 cm

12 Les Nanas Au Pouvoir *plate 8*
Stedeljik Museum, Amsterdam 1967
Color silkscreen, 95.5 x 65 cm
Lit.: Wichmann/Hufnagel, p. 157

**13 Je suis une sculpture de joie
en polyester.** *plate 9*
Gimpel Hanover Galerie, Zurich 1968
Color silkscreen, 66 x 47 cm

**14 Niki de Saint Phalle, Rainer von Diez,
'ICH'** *plate 10*
Staatstheater Kassel, 1968
Color silkscreen, 84 x 61 cm, signed by the artist
Lit.: Künstlerplakate, p. 130

15 Merry Christmas *plate 11*
Kunstverein für die Rheinlande und Westfalen,
Düsseldorf 1968/69
Color silkscreen, 80 x 60 cm
Lit.: Künstlerplakate, p. 131

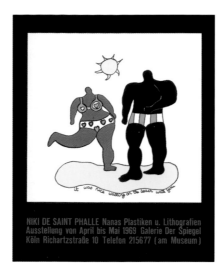

16 Nanas Plastiken u. Lithografien
Galerie Der Spiegel, Cologne 1969
Color silkscreen, 69.5 x 56 cm
Printing: Wery Siebdruck, Cologne

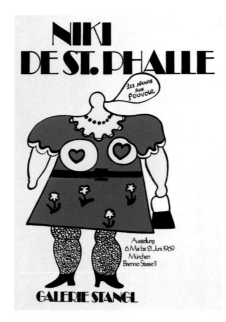

17 Les Nanas aux Pouvoir
Galerie Stangl, Munich 1969
Color silkscreen, 80 x 56.3 cm

18 Niki de Saint Phalle *plate 12*
Kunstmuseum Luzern, Lucerne 1969
Color silkscreen, 128 x 90 cm
Printing: J. E. Wolfensberger, Zurich

19 Le Rêve de Diane *plate 13*
Galerie Alexandre Iolas, Paris 1970
Color lithograph, 83 x 61 cm
Printing: Mourlot, Paris
Lit.: Museum Tinguely, p. 228

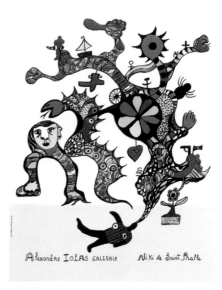

20 Niki de Saint Phalle
Galerie Alexandre Iolas, Paris 1970
Color lithograph, 89 x 61.5 cm
Printing: Clot, Bramsen and Georges, Paris
Lit.: Museum Tinguely, p. 228

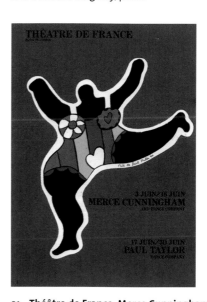

**21 Théâtre de France, Merce Cunningham
and Dance Company**
Paris 1970
Color offset, 58 x 39,5 cm
Versicherungskammer Bayern Collection

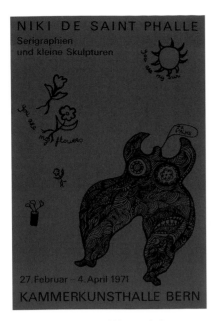

22 **Serigraphien und kleine Skulpturen**
Kammerkunsthalle Bern, 1971
Color serigraph, 42 x 27.3 cm

23 **Golem** *plate 14*
Israel Museum, Jerusalem 1972
Color silkscreen, 98.2 x 67 cm
'Golem' is a hollow sculpture made for a children's
playground in Jerusalem

24 **Les funerailles de Papa** *plate 16*
Galerie Iolas, Paris, Milan, New York 1972
Color offset, 84.7 x 60 cm
Printing: Sergio Tosi

25 **Eleventh New York Film Festival** presented by
the Film Society of Lincoln Center *plate 15*
New York 1973
Color silkscreen on heavy paper, 178 x 94 cm
Print-run: 300 copies of which 144 are numbered
and signed. The unusual portrait format was con-
ditioned by the billboard on the Lincoln Center.
Other Lincoln Center posters in this format
include works by the artists Josef Albers, David
Hockney and Jack Bush

26 **DADDY, Nikis böses erotisches Spiel
gegen Daddy** *plate 17*
Film by Peter Whitehead and Niki de Saint Phalle;
Constantin Film, produced by Peter Schamoni,
1973/74
Color silkscreen, 84 x 59.5 cm

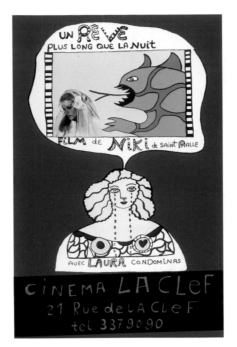

27 **Un Rêve plus long que la nuit**
Film by Niki de Saint Phalle
Cinéma la Clef, Paris 1974
Color silkscreen, 65.3 x 42.1 cm
Printing: A. Uidry, Bern
The address on black paper is an addition
Lit.: Museum Tinguely, p. 240

28 **Projets et réalisations
d'architecture** *plate 18*
Galerie Alexandre Iolas, Paris 1974
Color offset, 84 x 58 cm
Printing: Grafic Olimpia, Milan

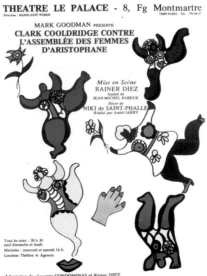

29 **Mark Goodman présente Clark Cooldridge
contre L'Assemblée des Femmes d'Aristophane**
Théâtre le Palace, Paris 1976
Color offset (A : 120 x 80 cm; B : 60 x 40 cm)
Lit.: Museum Tinguely, p. 240

30 **What is now known was once
only imagined** *plate 19*
Gimpel Weitzenhoffer Gallery, New York 1979
Offset, 45 x 61 cm
Lit.: Museum Tinguely, p. 256

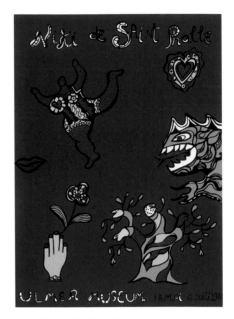

31 **Niki de Saint Phalle**
Ulmer Museum, Ulm 1980
Color silkscreen, 78.5 x 59.5 cm
For the 1999 Saint Phalle exhibition in Ulm Muse-
um a second edition was printed with 99 in the
bottom right-hand corner
Lit.: Museum Tinguely, p. 258 and Wichmann/
Hufnagel, p. 158

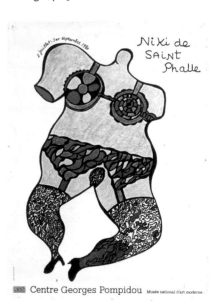

32 **Niki de Saint Phalle**
Centre Georges Pompidou, Musée national d'art
moderne, Paris 1980
Color offset, 70 x 50 cm
Printing: GS2 Udine, Italy

33 **Niki de Saint Phalle** *plate 21*
Moderna Museet, Stockholm 1981
Color offset, 68.3 x 48.2 cm
Printing: Lithografia Ponzio, Milan

34 18th Montreux Jazz Festival *plate 20*
Montreux, July 1984
Color silkscreen, 100 x 70 cm
Printing: A. Uldry, Bern
A later edition includes the name of the art consultant Pierre Keller
Lit.: Museum Tinguely, p. 267 and Wichmann/Hufnagel, p. 159

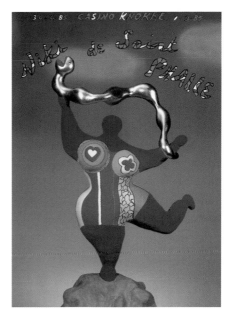

35 Casino Knokke
Knokke 1985
Color offset, 48 x 35 cm
The place name and date are missing on part of the edition

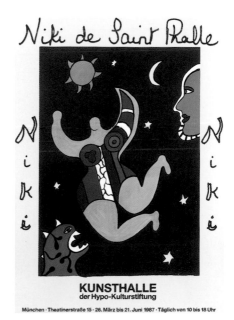

36 Niki de Saint Phalle
Kunsthalle der Hypo-Kulturstiftung, Munich 1987
Color silkscreen, 84.5 x 59.5 cm
Lit.: Museum Tinguely, p. 274

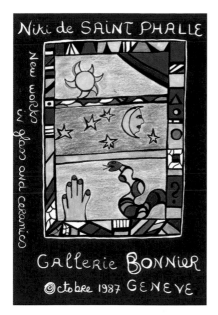

37 Niki de Saint Phalle, New works in Glass and Ceramics
Galerie Bonnier, Geneva 1987
Color offset, 63 x 42 cm
The motif appeared again in 1995 on a poster for Galerie Bürki, Bern
Lit.: Museum Tinguely, p. 287

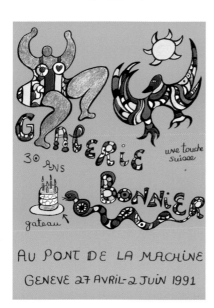

38 30 Ans Galerie Bonnier, Au pont de la machine
Galerie Bonnier, Geneva 1991
Color offset, 63 x 44 cm

39 Niki de Saint Phalle, Parfum Art *plate 22*
Association des Collectionneurs d'Echantillons et de Flacons à Parfums, Bourse d'échange, Halle Historiques, Ville de Milly-La-Fôret, 30 June 1991
Color silkscreen, 44.5 x 30 cm
Edition of 500 numbered copies
The same motif appears as a larger-sized, color silkscreen print (56 x 71 cm)
Lit.: Museum Tinguely, p. 287

**40 Niki de Saint Phalle,
l'inivitation au musée** *plate 23*
ARC - Musée d'Art Moderne de la Ville de Paris, 1993
Color silkscreen (Angel with Stars), 60 x 40 cm
Printing: Graficaza
Lit.: Museum Tinguely, p. 294

**41 Niki de Saint Phalle,
Her Life and Art** *plate 24*
McLellan Galleries, Glasgow 1993
Color offset, 59.4 x 42 cm
Text with black-and-white illustrations printed on reverse

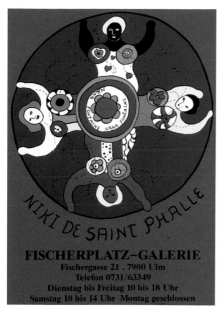

42 Niki de Saint Phalle, Nana – Fontaine
Fischerplatz-Galerie, Ulm 1993
Color silkscreen, 100 x 90 cm
Printing: Hans Schumacher, Ulm
Poster motif was used again in blue on a black background for Galerie Guy Pieters in Knokke
Lit.: Museum Tinguely, p. 285

**43 Niki de Saint Phalle,
Les Fiancés de Knokke** *plate 27*
Knokke, 1993
Color silkscreen on cardboard, 100 x 70 cm
Lit.: Museum Tinguely, p. 303

44 Niki de Saint Phalle *plate 28*
Musée d'Art et d'Histoire de Fribourg, 1993–1994
Color offset and silk print, 128 x 90 cm
Printing: Serigraphie A. Uldry, Bern
Lit.: Museum Tinguely, p. 313

45 Cirque Knie *plate 25*
1994
Color silkscreen, 70 x 50 cm
Lit.: Museum Tinguely, p. 313

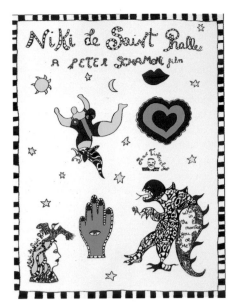

Jean Tinguely

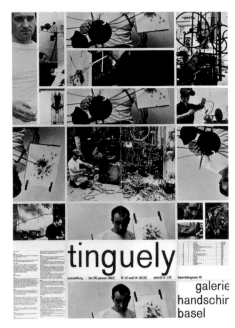

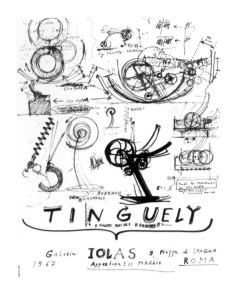

46 a Niki de Saint Phalle, A Peter Schamoni-Film
1994
Lithographie, 73 x 54 cm, Edition of 99

46 b Niki de Saint Phalle,
Ein Peter Schamoni-Film *plate 26*
1994
Color offset, 85,5 x 60,8 cm
Lit.: Museum Tinguely, p. 319

47 Musée Olympique Lausanne
Lausanne 1995
Color silkscreen, 100 x 70 cm
Printing: A. Uldry, Bern
Lit.: Museum Tinguely, p. 297

48 La Fête – Die Schenkung
Niki de Saint Phalle *plate 29*
Sprengelmuseum, Hanover 2000/01
Color offset, 84 x 59.3 cm

49 Niki de Saint Phalle *plate 30*
Museum Jean Tinguely, Basle 2001/02
Color offset, 128 x 89.3 cm and 86.3 x 53 cm

50 tinguely
Galerie Handschin, Basle 1962
Offset print, 119 x 84 cm
Multiple folds to form exhibition catalogue

51 Tinguely at the Dwan Gallery *plate 31*
Los Angeles 1963
Offset print, 75.5 cm x 63 cm

52 Jean Tinguely chez Galerie
Alexandre Iolas *plate 32*
Geneva 1964
Offset print, 43 x 30.3 cm

53 Tinguely, Machines for Galerie Iolas *plate 36*
Milan 1966
Color lithograph, 70 x 48 cm
Printing: Mourlot, Paris
Lit. : Künstlerplakate., p. 132

54 Machines de Tinguely
à la Galerie Iolas *plate 33*
Paris 1967
Offset, 70.5 x 48.5 cm
Printing: Mourlot, Paris

55 Tinguely
Galerie Iolas, Rome 1967
Offset print, 62.3 x 48.3 cm
Printing: Sergio Tosi, Milan

56 Le Rotozaza de Tinguely chez Galerie
Alexandre Iolas *plate 34*
Paris 1967
Color offset, 65 x 49 cm
Printing: Mourlot, Paris
There are three versions of the 'Rotozaza' sculpture. In 1967 the first version became a major attraction in Paris since it continuously shoots balls around the gallery and provokes the public into participating.

57 Requiem Pour Une Feuille Morte *plate 35*
1966–67
Galerie Denise René / Hans Mayer, Krefeld 1968
Silkscreen, 59 x 192 cm
A silkscreen print on cardboard also appeared, albeit without exhibition-specific details. The monumental machine was conceived for the Swiss pavilion at the World Fair in Montreal in 1967
Lit.: Künstlerplakate, p. 132

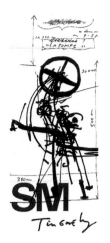

jean tinguely
tekeningen
stedelijk museum
amsterdam
5.12.68 - 19.1.69

58 jean tinguely, tekeningen
Stedelijk Museum Amsterdam, 1968/69
Offset print, 94 x 27 cm
List of exhibited works with illustrations printed
on reverse

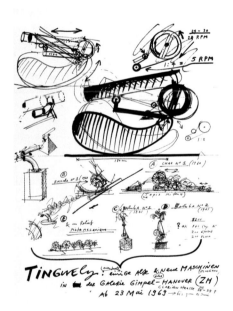

59 **Tinguely, eventuell einige Alte & oder Neue**
Maschinen-(Plastiken)
Galerie Gimpel & Hanover, Zurich 1969
Color offset, 80 x 59 cm
Poster also printed in a signed edition

60 **Sette (7) Balubas & 3–4 Machinas**
di Tinguely *plate 40*
Galerie Iolas, Milan 1970
Color offset with collage and green springs,
78.5 x 60 cm
The Baluba sculptures were made from 1961
onwards, influenced by his new partner,
Niki de Saint Phalle, who encouraged him to
include colored springs in his works
Lit.: Künstlerplakate p. 133

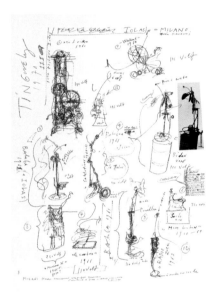

61 **Tinguely, Baluba**
Galerie Iolas, Milan 1970
Color offset with collage, 72.5 x 50.5 cm
An edition of signed posters was also published

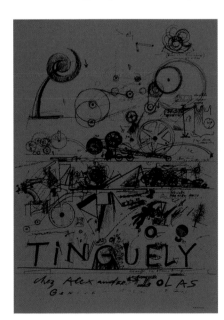

62 **Tinguely chez Alexander Iolas**
Geneva 1970
Offset print on red paper, 87 x 62 cm
Printing: Grafische Olimpia

63 **Jean Tinguely**
La Vittoria Milan 28. XI. 1970 *plate 40*
Cathredral square, Milan 1970
Offset print on cardboard, 90 x 68.3 cm
Edition Seriaal, Amsterdam 1971
Photo: Ad Petersen
Printing: Steendrukkerij de Jong & Co., Hilversum
The self-destroying sculptures were placed
outside Milan Cathedral. This 'happening' was
a public declaration of the death of 'Nouveau
Réalisme' on its 10th anniversary.
Lit.: Künstlerplakate, p. 134

64 **Tinguely** *plate 41*
Centre National d'Art Contemporain, Paris 1971
Offset print, 70 x 50 cm
Photo: Lennart Olson

65 **Maschinen Plastiken**
von Jean Tinguely *plate 42*
Kunsthalle Basel, Basle 1972
Offset print, 129 x 90 cm
Printing: Wassermann AG, Basle

66 **Maschinen-Plastiken**
von Tinguely *plate 43*
Kestnergesellschaft, Hannover 1972
Color offset, 84 x 60 cm
Printing: Wassermann AG, Basle
Lit.: Kunstmuseum Wolfsburg, p. 382

67 **Cenodoxus von Bidermann in einer Neu-**
anwendung von Düggelin, Forte, Tinguely
Salzburger Festspiele, Felsenreitschule, Salzburg
1972
Offset print, 72 x 52 cm (A: on white paper; B: on
pink paper)
Tinguely designed the stage set and costumes
Lit.: Kunstmuseum Wolfsburg, p. 101
Künstlerplakate, p. 136

68 Tristan Tzara: Das Gasherz, Première:
16 Sept 1972 *plate 38*
Düsseldorfer Schauspielhaus, Düsseldorf, 1972
Color silkscreen, 84 x 59 cm

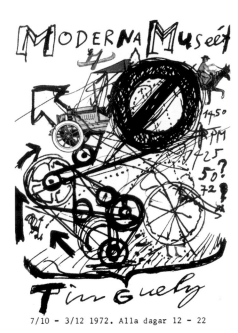

7/10 – 3/12 1972. Alla dagar 12 – 22

69 Tinguely
Moderna Museet, Stockholm 1972
Offset print, 100 x 70 cm
Catalogue and biography printed on the reverse
of part of the edition, and folded several times
Lit.: Kunstmuseum Wolfsburg, p. 383

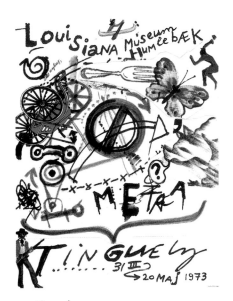

70 Tinguely
Louisiana Museum, Humlebaeck 1973
Color offset, 85 x 62 cm
Lit.: Kunstmuseum Wolfsburg, p. 386

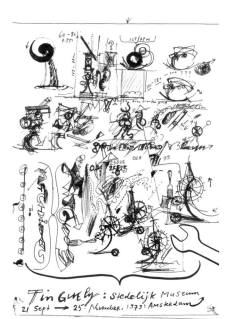

71 Tinguely
Stedelijk Museum, Amsterdam 1973
Color offset, 95 x 64 cm

72 Basler Theater *plate 44 a–e*
Basle 1974
Series of posters in 5 phases
Color silkscreen, 128 x 90 cm
Printing: J. A. Schneider, Basle
Week for week, the poster was pasted over with
subsequent versions, until the enigma turned
into an advertisement for Basle Theatre.

73 Jean Tinguely – Maschinen, Zeichnungen,
Dokumente, Fotos und Fotobuch von Leonardo
Bezzola *plate 45*
Museumsfoyer Solothurn, 1974
Color silkscreen, 76.5 x 50.8 cm
Printing: Albin Uldry, Bern

74 12th New York Film Festival *plate 39*
Film Society of Lincoln Center, New York 1974
Color silkscreen, 107 x 107 cm

75 Débricollages de Tinguely
Galerie Bischofberger, Zurich 1974/75
Color offset, 55 x 40 cm

76 Israel Museum, Tenth Anniversary
1975
Color offset, 98 x 65 cm
Printing: United Artists Ltd, Israel

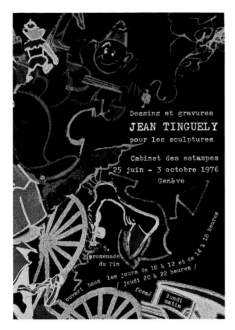

77 Jean Tinguely, Dessins et gravures pour les sculptures
Cabinet des Estampes, Geneva 1976,
Offset print, 94 x 64 cm

79 Biennale de Paris 1959–1967
Fondation nationale des arts plastiques et
graphiques, Paris 1977
Color offset, 63.3 x 40.5 cm

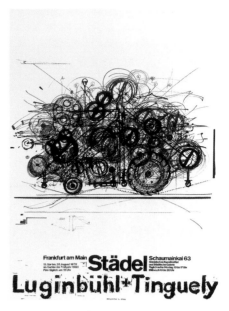

81 Städel, Luginbühl + Tinguely
Städelsches Kunstinstitut und Städtische Galerie,
Frankfurt 1979/80
Silkscreen, 84 x 60 cm
Printing: Albin Uldry, Bern
A second poster was designed by Bernhard
Luginbühl
Lit.: Kunstmuseum Wolfsburg, p. 323

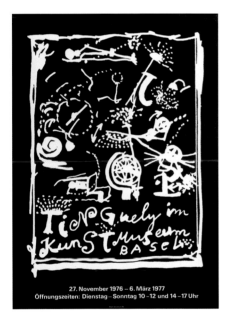

78 Tinguely im Kunstmuseum Basel
Basle 1976/77
Offset print, 129 x 90 cm
Printing: Wassermann AG, Basle

80 Festival d'Automne à Paris
Paris 1977
Color offset, 149.5 x 99.8 cm
Lit.: Künstlerplakate, p. 134

82 Tinguely à Flaine 1979–80
Centre d'Art de Flaine, 1979/80
Color offset, 70 x 51 cm

**83 Museum für Gegenwartskunst,
Basel** *plate 46*
Basle, 1980
Color silkscreen, 129 x 90 cm
Printing: Albin Uldry, Bern
Poster designed for the inauguration of the
museum for contemporary art in Basle.
Other posters were designed by Franz Eggen-
schwiler, Alfred Hofkunst and Bernhard Luginbühl

84 Jean Tinguely = Machines 1981 *plate 47*
Renault: Recherches, Art & Industrie, Centre Inter-
national de Création Artistique,
Abbaye de Sénanque, Gordes 1981
Offset print, 70.6 x 49.8 cm

85 Tinguely, Machines Recentes *plate 48*
Renault : Recherches, Art & Industrie, 1981
Abbaye de Sénanque, Gordes 1981
Offset print, 72 x 50 cm
Printing: Arte, Paris

86 Mémorial Jo Siffert *plate 49*
Course de côte St. Ursanne – Les Rangiers,
22–23 August 1981
Color offset, 70 x 49.5 cm
Jean Tinguely and the Swiss racing cyclist Jo
Siffert were close friends up until the latter's
death in an accident

87 André Heller, FLIC FLAC *plate 60*
Viennese Festival Weeks, 1982
Color offset, 84 x 59 cm

88 Tinguely im Kunsthaus Zürich *plate 51*
Zurich 1982
Color silkscreen, 128 x 90 cm
Printing: Albin Uldry, Bern
Lit.: Künstlerplakate, p. 136

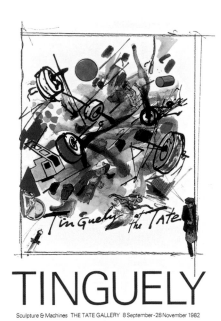

91 Tinguely at the Tate, Sculpture & Machines
The Tate Gallery, London 1982
Color offset, 76 x 51 cm
Printing: The Hillingdon Press, Uxbridge

**94 Monument pour Jo Siffert, Dessins des
Fontaines de Bâle – Paris & Fribourg**
Musée d'Art et d'Histoire, Fribourg 1984
Color offset, 60 x 38 cm
Tinguely presented his birthplace, Fribourg,
with a fountain in memory of Jo Siffert

**89 Max Bill, Daniel Spoerri, Cage, Rauschenberg,
Cesar, Luginbühl, Richard P. Lohse, ...**
Galerie Ziegler, Zurich 1982
Color offset, 60 x 43 cm

90 16-ième Festival de Jazz, Montreux *plate 52*
Montreux 1982
Color silkscreen, 100 x 70 cm
Printing: Albin Uldry, Bern
A later edition includes the name of the art con-
sultant Pierre Keller
Lit.: Künstlerplakate, p. 137

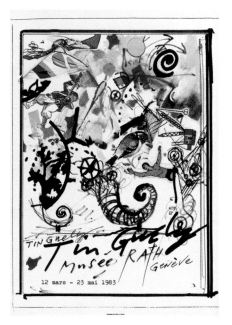

92 Tinguely
Musée Rath, Geneva 1983
Color silkscreen, 94 x 64 cm
Printing: Duo d'Arts s. a. Geneva

93 Tinguely in Het Stedelijk *plate 58*
Stedelijk Museum Amsterdam, 1983/84
Offset print, 87 x 58 cm
Lit.: Kunstmuseum Wolfsburg, p. 390

**95 11. Berner Kunstausstellung, Norbert Koschitz
– Elisabeth Zahnd – Jean Frédéric Schnyder –
Jean Tinguely ...**
Kunsthalle Bern, 1984
Color silkscreen, 100 x 70 cm
Printing: Albin Uldry, Bern
As one of the participants in a group exhibition,
Tinguely designed both the poster and the
invitations

96 25-ième Rose d'or Montreux 85 *plate 53*
Montreux 1985
Color silkscreen, 100 x 70 cm (A: on a black back-
ground; B: on a golden background)
Printing: Albin Uldry, Bern

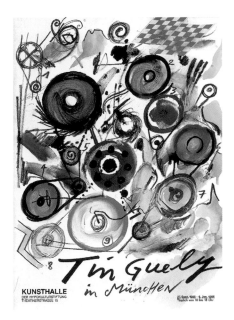

97 Tinguely in München
Kunsthalle der Hypokulturstiftung, Munich
1985/86
Color offset, 84 x 59.5 cm
Lit.: Kunstmuseum Wolfsburg, p. 391

98 Tinguely in München
Kunsthalle der Hypokulturstiftung, Munich
1985/86
Color silkscreen, 84 x 59.5 cm
Printing: Albin Uldry, Bern

99 luna luna, ein Ereignis von andré heller
Dammtorwiese, Hamburg 1986
Color offset (A: 119 x 84 cm; B: 84 x 59 cm;
C: 62 x 28 cm

100 Tinguely, Casino Knokke
Knokke 1986
Color offset, 67 x 49 cm

101 Tinguely
Galerie Bonnier, Genêve 1986
Color offset, 61 x 43 cm

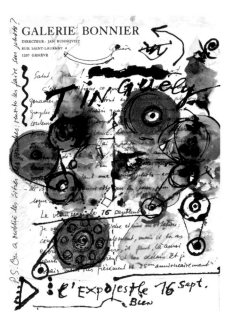

102 Tinguely
Galerie Bonnier, Geneva 1986
Color offset, 61 x 43 cm

103 Tinguely på Louisiana *plate 54*
Louisiana Museum Humlebaek, 1986
Color offset, 85 x 62 cm

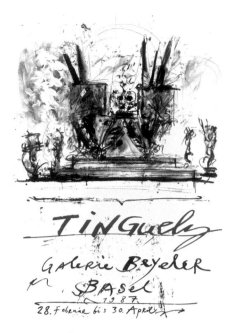

**107 Meta Maxi Maxi, penetrable & travesable &
Alufer, Bois totale, von Roll 1987**
Palazzo Grassi, Venice 1987
Color offset, 91 x 138 cm
Printing: Gruppo Editoriale Fabbri, S.p.A.

Color offset, 84 x 59 cm
The poster also exists without text in a reduced
size (64.5 x 43 cm)

110 Jean Tinguely, Pandemonium
Exlibris & Benteli Verlag, 1988
Color silkscreen, 55 x 43 cm

104 Tinguely
Galerie Beyeler, Basle 1987
Color offset, 87 x 59.4 cm

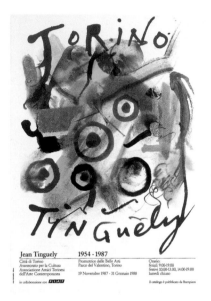

108 Torino - Tinguely, Jean Tinguely 1954–1987
Città di Torino, Parco del Valentino, Promotrice
delle Belle Arti, Turin 1987/88
Color offset, 100 x 70 cm

111 Tinguely *plate 56*
Centre Georges Pompidou, Musée national d'Art
moderne, Paris 1988/89
Color offset (A: 70 x 50 cm; B: 150 x 100 cm)

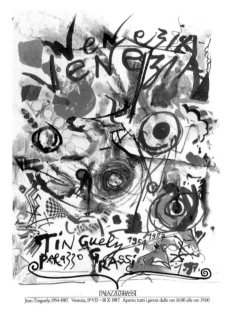

105 Venezia – Tinguely, Palazzo Grassi, 1954–87
Palazzo Grassi, Venice 1987
Color offset, 100 x 70 cm

**106 Tinguely * Hulten 87, una magia piu forte
della Morte** *plate 55*
Palazzo Grassi, Venice 1987
Color offset, 97 x 68 cm
Printing: Gruppo editoriale Fabbri S.p.A.
The same motif in a reduced format was used on
the cover of the catalogue for the
Palazzo Grassi

**109 Jim Whiting Show, unnatural bodies
part I & II**
Galerie Littmann, Basle 1988

112 Centre Culturel Suisse
Centre Culturel Suisse, Paris 1989
Color silkscreen, 89 x 70 cm
Printing: Albin Uldry, Bern

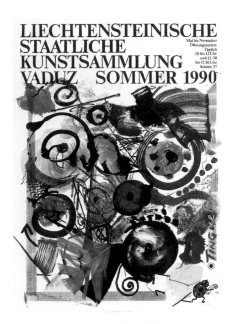

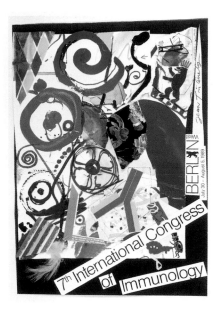

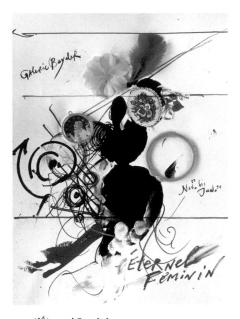

113 **Liechtensteinische Staatliche Kunstsammlung, Vaduz Sommer 1990**
Vaduz 1990
Color silkscreen, 128 x 91 cm und 100 x 71 cm
Printing: Albin Uldry, Bern

115 **7th International Congress of Immunology**
Berlin West 1989
Color offset, 59 x 42 cm

117 **L'Éternel Feminin**
Galerie Beyeler, Basle 1989/90
Color offset, 86 x 62 cm
The catalogue for the group exhibition of works by Degas, Picasso, Leger, Dubuffet and Baselitz, among others, includes a four-page foldout with a handwritten text by Jean Tinguely on the 'Eternal Female'

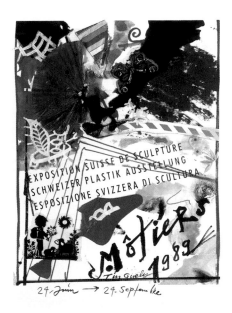

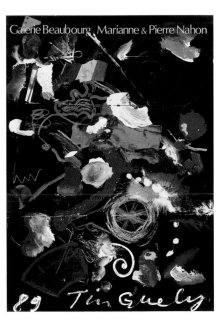

114 **Exposition Suisse de Sculpture, Schweizer Plastik Ausstellung, Esposizione Svizzera di Scultura, Môtiers 1989**
Motiers 1989
Color silkscreen (A: 128 x 91 cm; B: 64 x 45 cm)
Printing: Albin Uldry, Bern

116 **89 Tinguely, Galerie Beaubourg, Marianne & Pierre Nahon**
Paris 1989
Color silkscreen, 76 x 56 cm

118 a **Tinguely, Moscou**
Moscow 1990
Color silkscreen, 100 x 70 cm (A: Black/white)
Printing: Albin Uldry, Bern
Editor: Pro Helvetia, Zurich

118 b **Tinguely, Moscou** *plate 53*
Moscow 1990
Color silkscreen, 100 x 70 cm (B: yellow/red)
Printing: Albin Uldry, Bern
Editor: Pro Helvetia, Zurich

119 Jean Tinguely
Retable de l'Abondance occidentale et du
Mercantilisme totalitaire …
Moscow 1990
Color offset, 68 x 46.5 cm
This retrospective, sponsored by the Pro Helvetia
Kulturstiftung, was held at the Tretyakov Gallery.

120 World Ice Hockey, Championships, A-Series
Bern, Fribourg 1990
Color offset, 128 x 91 cm
In addition to this version, an edition of 300 was
printed with a black drawing framing the motif

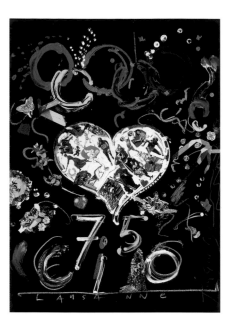

121 75 CIO, Lausanne
Internationales Olympisches Komitee,
Lausanne 1990
Color silkscreen, 128 x 91 cm

122 Jean Tinguely by Dubinsky
Galerie Dubinsky, Zurich 1990
Offset print, 128 x 91 cm

123 Jean Tinguely, »de la chasse«
chez Eric van de Weghe
Galerie Eric van de Weghe, Brussels 1990/91
Color offset, 71 x 48 cm

124 Jean Tinguely, la Nouvelle Galerie très belle!
Eric van de Weghe
Galerie Eric van de Weghe, Brussels 1990/91
Color offset, 71 x 48 cm

125 le 4 ième Grand Prix à Gollion *plate 50*
6/7 October 1990
Color offset, 59.5 x 42 cm

126 Gebrüder Knie, Schweizer National-Cirkus,
Fratelli Knie, Circo Nazinale Svizzero SA, Knie
Frères, Cirque National Suisse
Zurich 1991
Color offset, 128 x 91 cm
Printing: Rentsch AG, Trimbach 1991

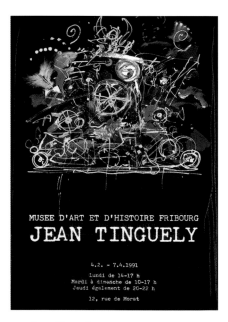

127 Jean Tinguely
Musée d'Art et d'Histoire, Fribourg 1991
Color offset (A: 128 x 91 cm; B: 59.3 x 42 cm)
In addition, an edition of 100 signed posters was
also published. The exhibition was an expanded
version of the Moscow show

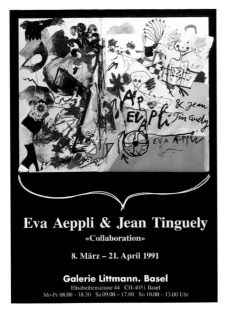

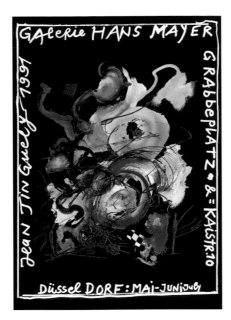

133 **Voliere Dromesko** *plate 61*
Paris 1991
Color silkscreen (A: 128 x 90 cm; B: 100 x 70 cm)
Reprinted in Brussels 1995
Printing: A. Uldry, Brussels

128 **Eva Aeppli & Jean Tinguely, Collaboration**
Galerie Littmann, Basle 1991
Color offset, 84 x 59 cm

130 **Jean Tinguely 1991**
Galerie Hans Mayer, Düsseldorf 1991
Color offset, 84 x 59.3 cm

131 **Fêtes des Vignerons** *plate 59*
Palais de Beaulieu, Lausanne, 28–30 June 1991
Color silkscreen, 128 x 91 cm
Printing: Albin Uldry, Bern
Published on the occasion of Switzerland's 700th
anniversary.

134 **Bar des Arts, Basel, W Frank**
Bar-Café des Arts & Cocktail-Bar, Basle 1990
Color offset, 100 x 70 cm

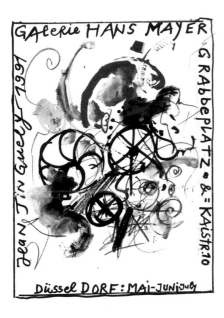

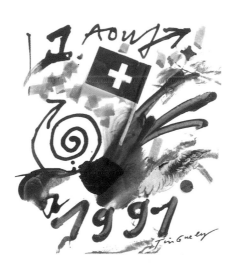

129 **Jean Tinguely 1991**
Galerie Hans Mayer, Düsseldorf 1991
Color offset, 84 x 59.3 cm

132 **1. Aout 1991**
Color silkscreen, 100 x 70 cm
Printing: Albin Uldry, Bern
Published on the occasion of Switzerland's 700th
anniversary.

135 **Tinguely, Nachtschattengewächse**
Kunsthaus Wien, Vienna 1991
Color offset on cardboard, 84 x 59 cm

136 **Jean Tinguely, 8 Philosophen
[Philo[sophisten]** *plate 62*
Galerie Dubinsky Fine Arts, Zurich 1991
Offset print, 100 x 70 cm

Biographies

Niki de Saint Phalle, 29. 10. 1930–21. 05. 2002
Born in Neuilly-sur-Seine, grows up in New York

Jean Tinguely, 22. 05. 1925–30. 08. 1991
Born in Fribourg, Switzerland, grows up in Basle

Jean Tinguely goes to the General Trades School in Basle from 1941–45, learning basic art design and art history. He works as a window dresser.

Niki de Saint Phalle comes from a French aristocratic family. She works as a photo model for *Vogue, Harper's Bazaar* and *Life*. She is self-taught, and following a nervous breakdown turns to art for self-therapy.

1954 Jean Tinguely's first exhibition at the Galerie Arnaud, Paris (*Sculptures et Reliefs Mécaniques de Tinguely*).
Makes acquaintance of Pontus Hultén, who later supports both artists as director of the Moderna Museet in Stockholm, the Pompidou Centre in Paris and many other international institutions and bodies.

1955 Jean Tinguely's first exhibition successes, taking part in *Le Mouvement* exhibition at the Galerie Clért in Paris and *Internationale Eisenplastik* (International Iron Sculpture) at the Kunsthalle in Berne.
Makes acquaintance of Yves Klein and strikes up a close friendship with him.

1956 Niki de Saint Phalle's first solo exhibition at the Galerie Le Restaurant in St. Gallen.
Niki de Saint Phalle and Jean Tinguely first meet in Paris; at the time, Jean is married to Eva Aeppli and Niki to Harry Matthews.

1959 Happening with two cyclists and Tinguely's pedal-driven drawing machine *Cyclomatic* at the Institute of Contemporary Arts in London.

1960 Niki de Saint Phalle and Jean Tinguely become an artist couple. They share a studio in the Impasse Ronsin in Paris. Their affair is not only personal but also an intensive working partnership. The love affair only lasts a few years, but the mutual inspiration and support endures till the death of Jean Tinguely in 1991.
Jean stages his action *Hommage à New York* in the garden of the Museum of Modern Art in New York. As intended, the sculpture is destroyed during the action. The museum henceforth treats his work with reserve.
Pierre Restany founds the Nouveaux Réalistes in Paris. Tinguely is among the founding members, while Saint Phalle joins in 1961. Other members include Arman, César, Dufrêne, Hains, Klein, Raysse, Rotella, Spoerri, Villeglé, Duchamp and Christo. Participation in several demonstrations.
Jean and Niki cause a flurry of excitement by parodying the painting of Abstract Expressionism and Art Informel—Jean with his *Métamatic* machines (1959), which generate abstract

Biografien

Niki de Saint Phalle, 29. 10. 1930–21. 5. 2002
Geboren in Neuilly-sur-Seine, aufgewachsen in New York

Jean Tinguely, 22. 5. 1925–30. 8. 1991
Geboren in Fribourg, aufgewachsen in Basel

Jean Tinguely besucht 1941–45 zeitweilig die Allgemeine Gewerbeschule in Basel, wo er Grundkenntnisse im künstlerischen Gestalten sowie in Kunstgeschichte erwirbt. Er arbeitet als Schaufensterdekorateur.

Niki de Saint Phalle stammt aus einer französischen Adelsfamilie, sie arbeitet als Fotomodell bei *Vogue, Harper's Bazaar* und *Life Magazine*. Sie ist Autodidaktin und gelangt nach einem Nervenzusammenbruch zur Kunst in Selbsttherapie.

1954 Erste Einzelausstellung von Jean Tinguely in der Galerie Arnaud, Paris: ›Sculptures et Reliefs mécanique de Tinguely‹.
Bekanntschaft mit Pontus Hultén, der als späterer Direktor des Moderna Museet in Stockholm, des Centre Georges Pompidou in Paris und in vielen anderen internationalen Institutionen und Gremien beide Künstler unterstützt.

1955 Jean Tinguely hat erste Ausstellungserfolge, er ist beteiligt an den Ausstellungen ›Le Mouvement‹ in der Galerie Clért in Paris und ›Internationale Eisenplastik‹ in der Kunsthalle Bern.
Bekanntschaft mit Yves Klein und Beginn einer engen Freundschaft mit ihm.

1956 Erste Einzelausstellung von Niki de Saint Phalle in der Galerie Le Restaurant in St. Gallen.
Niki de Saint Phalle und Jean Tinguely lernen sich in Paris kennen; Jean ist damals mit Eva Aeppli verheiratet und Niki mit Harry Matthews.

1959 Happening mit zwei Radsportlern und Tinguelys pedalbetriebener Zeichenmaschine *Cyclomatic* im Institute of Contemporary Arts in London.

1960 Niki de Saint Phalle und Jean Tinguely werden ein Künstlerpaar. Sie teilen sich ein Atelier in der Impasse Ronsin in Paris. Die Künstler verbindet nicht nur eine Lebens-, sondern auch eine intensive Arbeitsgemeinschaft. Ihre Liebesbeziehung besteht nur wenige Jahre, die gegenseitige Inspiration und Unterstützung währt jedoch bis zu Jean Tinguelys Tod 1991.
Jean führt seine Aktion *Hommage à New York* im Garten des Museum of Modern Art in New York auf: Wie beabsichtigt wird die Skulptur durch die Aktion zerstört. Das Museum steht seither seiner Arbeit reserviert gegenüber.
Pierre Restany gründet die Gruppe der ›Nouveaux Réalistes‹ in Paris. Tinguely gehört zu den Gründungsmitgliedern, Saint Phalle beteiligt sich ab 1961. Zur Gruppe gehören außerdem Arman, César, Dufrêne, Hains, Klein, Raysse, Rotella, Spoerri, Villeglé, Duchamp und Christo. Beteiligung an mehreren Manifestationen.
Das Künstlerpaar macht Furore, weil sie die Male-

Biographies

Niki de Saint Phalle, 29 octobre 1930–21 mai 2002
Née à Neuilly-sur-Seine, enfance à New York

Jean Tinguely, 22 mai 1925–30 août 1991
Né à Fribourg (Suisse), enfance à Bâle

De 1941 à 1945, Jean Tinguely fréquente l'École des arts et métiers de Bâle, où il acquiert des connaissances fondamentales en composition artistique ainsi qu'en histoire de l'art. Il travaille comme décorateur de vitrines.

Niki de Saint Phalle naît dans une famille de l'aristocratie française, elle travaille comme modèle pour *Vogue, Harper's Bazaar* et *Life Magazine*. Elle est autodidacte et c'est après une dépression nerveuse qu'elle arrive à l'art, en guise d'autothérapie.

1954 Première exposition personnelle de Jean Tinguely à la galerie Arnaud, Paris : « Sculptures et reliefs mécaniques de Tinguely ».
Rencontre Pontus Hultén, futur directeur du Moderna Museet de Stockholm, du Centre Georges Pompidou à Paris et de nombreuses autres institutions et commissions, qui soutiendra les deux artistes.

1955 Jean Tinguely connaît ses premiers succès d'expositions, il participe aux expositions « Le mouvement » à la galerie Clert à Paris et « Internationale Eisenplastik » à la Kunsthalle de Berne.
Rencontre d'Yves Klein et début d'une grande amitié.

1956 Première exposition personnelle de Niki de Saint Phalle à la galerie Le Restaurant à Saint-Gall. Niki de Saint Phalle et Jean Tinguely se rencontrent à Paris. Jean est alors marié à Eva Aeppli et Niki à Harry Matthews.

1959 Happenning avec deux cyclistes sportifs et la machine-dessin à pédales *Cyclomatic* à l'Institute of Contemporary Art de Londres.

1960 Niki de Saint Phalle et Jean Tinguely font désormais un couple d'artistes. Ils partagent un atelier impasse Ronsin, à Paris. Les deux artistes sont liés non seulement par une communauté de vie, mais aussi par une intense communauté de travail. Leur relation amoureuse ne dure que quelques années, mais l'inspiration et le soutien mutuel persisteront jusqu'à la mort de Jean, en 1991.
Jean réalise son action *Hommage* dans le jardin du Museum of Modern Art à New York : comme intentionnellement, la sculpture est détruite par l'action. Depuis, le MoMA reste est face au travail de Tinguely. Pierre Restany fonde le groupe des « Nouveaux Réalistes » à Paris. Tinguely fait partie des membres fondateurs. En 1961, Niki de Saint Phalle rejoint le groupe qui compte en outre Arman, César, Dufrêne, Hains, Klein, Raysse, Rotella, Spoerri, Villeglé, Duchamp et Christo. Les « Nouveaux Réalistes » participent à plusieurs manifestations.

pictures mechanically, and Niki with her shooting happenings, peppering with rifle shot canvases and reliefs containing pouches of paint.

1961 Joint activities:
Participation in a concert with John Cage, David Tudor, Robert Rauschenberg and Jasper Johns at the American embassy in Paris.
Participation in the *Bewogen-Beweging* exhibition at the Stedelijk Museum, Amsterdam, and subsequently at the Moderna Museet, Stockholm and Louisiana Museum, Humlebæk.
Participation in the *Art of Assemblage* exhibition at the Museum of Modern Art, New York.

1962 Both take part in the *Dylaby-Labyrinthe Dynamique* exhibition at the Stedelijk Museum, Amsterdam. Nine walk-in spaces are created in collaboration with Raysse, Ultvedt and Spoerri.

1964 Tinguely produces his monumental *Eureka* sculpture for the Swiss Provincial Exhibition in Lausanne.
Tinguely is invited to documenta III in Kassel.
Niki de Saint Phalle has a solo exhibition at the Hanover Gallery in London. She produces her first Nana figures.

1971–1973 Tinguely produces his great *Double Helix* spiral for the courtyard of Hoffmann-La Roche AG's Basle Institute of Immunology.
Niki de Saint Phalle designs *Golem* for a children's playground in Jerusalem, *Le Dragon* for Knokke (Belgium) and three large Nana figures for the city of Hanover.
The iron structures for Niki's sculptures are constructed by Tinguely.

1977 Dedication of Tinguely's *Fasching* (Shrovetide) *Fountain* in Theaterplatz, Basle.
Niki de Saint Phalle and Jean Tinguely are under contract to the same galleries, including Iolas, Handschin, Dwan, Gimpel-Hanover and Bonnier. Their first retrospectives are put on. They both set great store on having separate exhibition biographies. Niki de Saint Phalle produces several films of her own, including *Daddy* (1972) and *A Dream Longer than Night* (1974). In parallel, she works with Tinguely on several joint sculptural projects.

Retrospectives (selection)

1967 Stedelijk Museum, Amsterdam: Niki de Saint Phalle's first retrospective

1971–73 Jean Tinguely retrospective at the Centre National d'Art Contemporain in Paris, the Kunsthalle in Basle, the Kestner-Gesellschaft in Hanover, the Moderna Museet in Stockholm, the Louisiana Museum in Humlebæk and the Stedelijk Museum, Amsterdam

1980 Niki de Saint Phalle retrospective at the Musée National d'Art Moderne in the Pompidou Centre, Paris, the Sprengel Museum, Hanover and the Moderna Museet, Stockholm

rei des Abstrakten Expressionismus und des Informel parodieren: Jean mit seinen seit 1959 entwickelten *Métamatic*-Maschinen, die auf mechanische Weise abstrakte Bilder erzeugen, und Niki, die mit einem Karabiner auf Leinwände und Reliefs zielt, die mit Farbe präpariert sind.

1961 Gemeinsame Aktivitäten:
Mitwirkung bei einem Konzert mit John Cage, David Tudor, Robert Rauschenberg und Jasper Johns in der amerikanischen Botschaft in Paris.
Teilnahme an der Ausstellung *Bewogen-Beweging* im Stedelijk Museum, Amsterdam, sowie anschließend im Moderna Museet, Stockholm, und Louisiana Museum, Humlebaek.
Teilnahme an der Ausstellung ›The Art of Assemblage‹ im Museum of Modern Art, New York.

1962 Beide beteiligen sich an der Ausstellung ›Dylaby-Labyrinthe Dynamique‹ im Stedelijk Museum, Amsterdam. In Zusammenarbeit mit Raysse, Ultvedt und Spoerri entstehen neun begehbare Räume.

1964 Für die Schweizer Landesausstellung in Lausanne realisiert Tinguely seine monumentale Skulptur *Eureka*.
Tinguely wird eingeladen zur ›documenta III‹ in Kassel.
Niki de Saint Phalle hat eine Einzelausstellung in der Hanover Gallery in London. Erste Nana-Figuren entstehen.

1971–1973 Für den Hof des Basler Instituts für Immunologie der Hoffmann-La Roche AG entsteht Tinguelys große Spirale *Doppel-Helix*.
Niki de Saint Phalle konzipiert den *Golem* für einen Kinderspielplatz in Jerusalem, *Le Dragon* für Knokke (Belgien) sowie drei große Nana-Figuren für die Stadt Hannover.
Die Eisenkonstruktionen von Nikis Skulpturen werden von Tinguely gebaut.

1977 Einweihung von Tinguelys *Fasnachtsbrunnen* auf dem Basler Theaterplatz.
Niki de Saint Phalle und Jean Tinguely sind bei den gleichen Galerien unter Vertrag, u.a. bei Iolas, Handschin, Dwan, Gimpel-Hanover und Bonnier. Ihre ersten Retrospektiven werden gezeigt. Jeder von beiden legt Wert auf eine eigenständige Ausstellungsbiografie. Niki de Saint Phalle realisiert mehrere eigene Filme, darunter *Daddy* (1972) und *Ein Traum, länger als die Nacht* (1974). Daneben erarbeitet sie mit Tinguely mehrere gemeinsame Skulpturprojekte.

Retrospektiven (Auswahl)

1967 Stedelijk Museum, Amsterdam: erste Retrospektive von Niki de Saint Phalle

1971–73 Retrospektive von Jean Tinguely im Centre National d'Art Contemporain in Paris, in der Kunsthalle Basel, der Kestner-Gesellschaft in Hannover, im Moderna Museet, Stockholm, im Louisiana Museum, Humlebaek, und im Stedelijk Museum, Amsterdam

Le couple fait fureur en parodiant l'expressionnisme abstrait et l'Informel : Jean avec ses machines *Métamatic* qui, à partir de 1959, donnent lieu à des images abstraites par procédé mécanique. Niki tire à la carabine sur des toiles et des reliefs préparés à la peinture.

1961 Activités communes :
Contribution à un concert avec John Cage, David Tudor, Robert Rauschenberg et Jasper Johns à l'ambassade américaine à Paris.
Participation à l'exposition ‹Bewogen-Beweging› au Stedelijk Museum d'Amsterdam, au Moderna Museet de Stockholm et au Louisiana Museum de Humlebaek.
Participation à l'exposition ‹The Art of Assemblage› au Museum of Modern Art de New York.

1962 Prennent part tous les deux à l'exposition ‹Dylaby-Labyrinthe Dynamique› au Stedelijk Museum, à Amsterdam. Neuf espaces ouverts naissent d'une collaboration avec Raysse, Ultvedt et Spoerri.

1964 *Eureka*, sculpture monumentale de Tinguely, est réalisée pour la Schweizer Landesaustellung, à Lausanne.
Niki de Saint Phalle expose seule à la Hanover Gallery de Londres. Premières *Nanas*.

1971–1973 Pour la cour de l'institut bâlois d'immunologie de la société Hoffmann-La Roche, grande spirale *Double Hélice* de Tinguely.
Niki de Saint Phalle conçoit le *Golem* pour une aire de jeux à Jérusalem, *Le Dragon* pour Knokke (Belgique) et trois grandes sculptures de *Nanas* pour la ville de Hanovre.
Les constructions métalliques de Niki de Saint Phalle sont construites par Tinguely.

1977 Inauguration de la *Fasnachtsbrunnen* de Tinguely sur la Theaterplatz de Bâle.
Niki de Saint Phalle et Jean Tinguely sont sous contrat dans les mêmes galeries, entre autres chez Iolas, Handschin, Dwan, Gimpel-Hanovre et Bonnier. Premières rétrospectives. Ils insistent pour avoir chacun leur propre biographie d'exposition. Niki de Saint Phalle réalise plusieurs films, dont *Daddy* (1972) et *Un rêve plus long que la nuit* (1974). Par ailleurs, elle élabore avec Tinguely plusieurs projets de sculptures en commun.

Rétrospectives (sélection)

1967 Stedelijk Museum, Amsterdam : première rétrospective de Niki de Saint Phalle.

1971–1973 Rétrospective de Jean Tinguely au Centre national d'art contemporain de Paris, à la Kunsthalle de Bâle, à la Kestner-Gesellschaft de Hanovre, au Moderna Museet de Stockholm, au Louisiana Museum de Humlebaek et au Stedelijk Museum d'Amsterdam.

1980 Rétrospective de Niki de Saint Phalle au Musée national d'art moderne au Centre Georges Pompidou, Paris, au Sprengel-Museum, à Hanovre, et au Moderna Museet, à Stockholm.

1982/83 Jean Tinguely retrospective at the Kunsthaus in Zurich, the Tate Gallery in London, the Palais des Beaux-Arts, Brussels and the Musée d'Art et d'Histoire, Geneva

1987 Niki de Saint Phalle retrospective at the Kunsthalle der Hypo-Kulturstiftung in Munich. Her first retrospective in the USA is put on by Nassau County Museum of Fine Art in Roslyn, Long Island.

1987/88 Jean Tinguely retrospective at the Palazzo Grassi, Venice in the Promotrice delle Belle Arti, Turin, and at the Musée National d'Art Moderne at the Pompidou Centre, Paris.

1990 Jean Tinguely exhibition at the Tretyakov Gallery, Moscow.

1992 Niki de Saint Phalle retrospective at the Art and Exhibition Hall of the Federal Republic of Germany in Bonn

2000 Niki de Saint Phalle exhibition at the Tinguely Museum in Basle

Joint sculptural projects (selection)

1966 *Hon*, a huge walk-in Nana, is devised in collaboration with Per Olov Ultvedt at the Moderna Museet in Stockholm; Jean and Niki join forces with Martial Raysse to do the stage sets for Roland Petit's ballet *Eloge de la Folie*.

1967 *Le Paradis Fantastique* for the French pavilion at Expo in Montréal; Tinguely also does his *Requiem pour une Feuille Morte* for the Swiss pavilion.

1977 The huge *Le Crocrodrome* sculpture, a collaborative work with Daniel Spoerri and Bernhard Luginbühl, celebrates the opening of the Pompidou Centre in Paris.

1982/83 The Stravinsky Fountain is installed in the square next to the Pompidou Centre.

1988 Jean and Niki work on a fountain for the Loire château of Chinon, a commission by the French president François Mitterand.

In 1969, Jean Tinguely begins a major project for *La Tête* in the woods near Milly-la-Forêt, with input by Niki de Saint Phalle, Bernhard Luginbühl, Larry Rivers, Daniel Spoerri etc. In 1979, Niki de Saint Phalle begins the *Tarot Garden* in southern Tuscany in collaboration with Jean Tinguely.

Foundations

1996 Niki de Saint Phalle donates many important works from the estate of Jean Tinguely to the newly established Jean Tinguely Museum in Basle.

1999/2000 Niki de Saint Phalle gives a substantial number of her works to the Sprengel Museum in Hanover and the museum in Nice.

1980 Retrospektive von Niki de Saint Phalle im Musée national d'art moderne im Centre Georges Pompidou, Paris, im Sprengel-Museum, Hannover, und im Moderna Museet, Stockholm

1982/83 Retrospektive von Jean Tinguely im Kunsthaus Zürich, in der Tate Gallery, London, im Palais des Beaux-Arts, Brüssel, und im Musée d'Art et d'Histoire, Genf

1987 Retrospektive von Niki de Saint Phalle in der Kunsthalle der Hypo-Kulturstiftung, München. Ihre erste Retrospektive in den USA richtet das Nassau County Museum of Fine Art in Roslyn, Long Island, aus

1987/88 Retrospektive von Jean Tinguely im Palazzo Grassi, Venedig, im Promotrice delle Belle Arti, Turin, und im Musée national d'art moderne im Centre Georges Pompidou, Paris

1990 Ausstellung von Jean Tinguely in der Tretjakov-Galerie, Moskau

1992 Retrospektive von Niki de Saint Phalle in der Kunst- und Ausstellungshalle der Bundesrepublik Deutschland, Bonn

2000 Ausstellung von Niki de Saint Phalle im Tinguely-Museum in Basel

Gemeinsame Skulpturprojekte (Auswahl)

1966 In Zusammenarbeit mit Per Olov Ultvedt ensteht *Hon*, eine begehbare Riesen-Nana, im Moderna Museet von Stockholm; gemeinsam mit Martial Raysse gestalten die Künstler Bühnendekorationen für das Ballett *Eloge de la Folie* von Roland Petit

1967 Zur Weltausstellung in Montréal entsteht *Le paradis fantastique* für den französischen Pavillon; zusätzlich realisiert Tinguely sein *Requiem pour une feuille morte* für den Schweizer Pavillon

1977 Anlässlich der Eröffnung des Centre Georges Pompidou in Paris konzipieren sie die Riesenskulptur *Le Crocrodrome* in Zusammenarbeit mit Daniel Spoerri und Bernhard Luginbühl

1982/83 Für den Platz neben dem Centre Georges Pompidou entsteht der *Stravinsky-Brunnen*

1988 Im Auftrag des französischen Staatspräsidenten François Mitterand Realisierung eines Brunnens für Château Chinon

Ab 1969 entsteht das Großprojekt *La Tête* von Jean Tinguely im Wald bei Milly-la-Forêt unter Mitwirkung von Niki de Saint Phalle, Bernhard Luginbühl, Larry Rivers, Daniel Spoerri u.a. 1979 beginnt Niki de Saint Phalle den *Tarot-Garten* in der Toskana in Zusammenarbeit mit Jean Tinguely

Stiftungen

1996 Niki de Saint Phalle stiftet viele wichtige Werke aus dem Nachlass Jean Tinguelys an das neugegründete Museum Jean Tinguely in Basel

1999/2000 Niki de Saint Phalle übergibt bedeutende Stiftungen ihres Werkes an das Sprengel-Museum in Hannover und das Museum in Nizza

1982–1983 Rétrospective de Jean Tinguely au Kunsthaus de Zurich, à la Tate Gallery de Londres, au Palais des Beaux-Arts de Bruxelles et au Musée d'art et d'histoire de Genève.

1987 Rétrospective de Niki de Saint Phalle à la salle d'expositions de la Hypo-Kulturstiftung de Munich. Sa première rétrospective américaine est organisée par le Nassau County Museum of Fine Arts, Roslyn, Long Island.

1987–1988 Rétrospective de Jean Tinguely au Palazzo Grassi de Venise, au Promotrice delle Belle Arti de Turin et au Musée national d'art moderne du Centre Georges Pompidou, à Paris.

1990 Exposition de Jean Tinguely à la galerie Tretiakov à Moscou.

1992 Rétrospective de Niki de Saint Phalle à la Kunst- und Austellungshalle der Bundesrepublik Deutschland (Bonn).

2000 Exposition de Niki de Saint Phalle au Musée Tinguely de Bâle.

Projets de sculptures en commun (sélection)

1966 En collaboration avec Per Olov Ultvedt, *Hon*, une *Nana* géante et arpentable au Moderna Museet de Stockholm. Avec Martial Raysse, les deux artistes créent les décors pour la scène du ballet *Éloge de la Folie* de Roland Petit.

1967 Pour l'Exposition universelle de Montréal, création du *Paradis fantastique* pour le pavillon français ; de plus, Tinguely réalise son *Requiem pour une feuille morte* pour le pavillon suisse.

1977 En collaboration avec Daniel Spoerri et Bernhard Lunginbühl, conception de la sculpture monumentale *Le Crocodrome* pour l'ouverture du Centre Georges Pompidou de Paris.

1982/1983 *Fontaine Stravinsky*, pour la place à côté du Centre Georges Pompidou, Paris.

1988 Commande du Président François Mitterrand pour la realisation de la Fontaine de Château-Chinon.

À partir de 1969, projet monumental *La Tête* de Jean Tinguely, près de Milly-la-Forêt, en collaboration avec, entre autres, Niki de Saint Phalle, Bernhard Luginbühl, Larry Rivers, Daniel Spoerri. En 1979, Niki de Saint Phalle entreprend la réalisation du *Jardin du Tarot* en Toscane, avec Jean Tinguely.

Donations

1996 Niki de Saint Phalle donne de nombreuses œuvres importantes de la succession de Jean Tinguely au Musée Jean Tinguely nouvellement fondé à Bâle.

1999/2000 Niki de Saint Phalle donne des fonds importants de son œuvre au Sprengel-Museum de Hanovre et au Musée de Nice.